阮靈

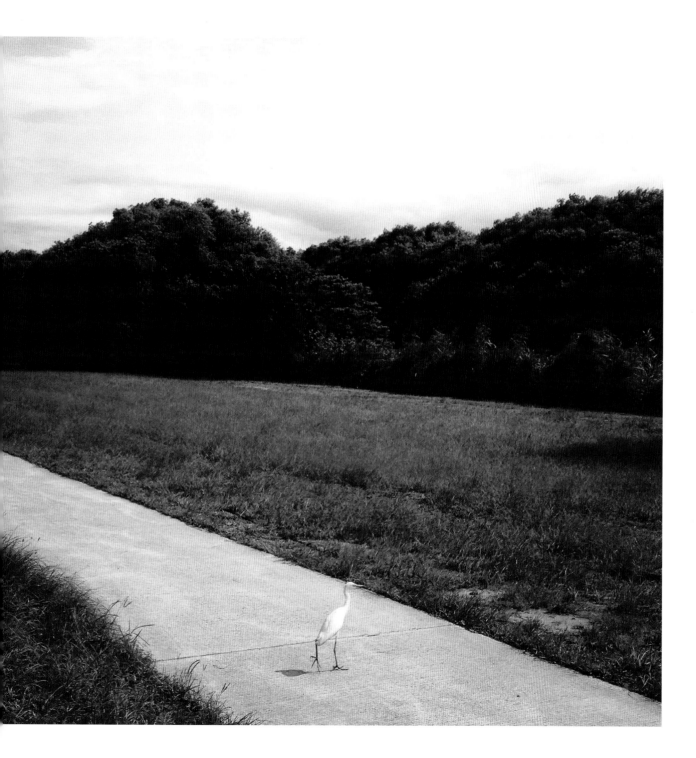

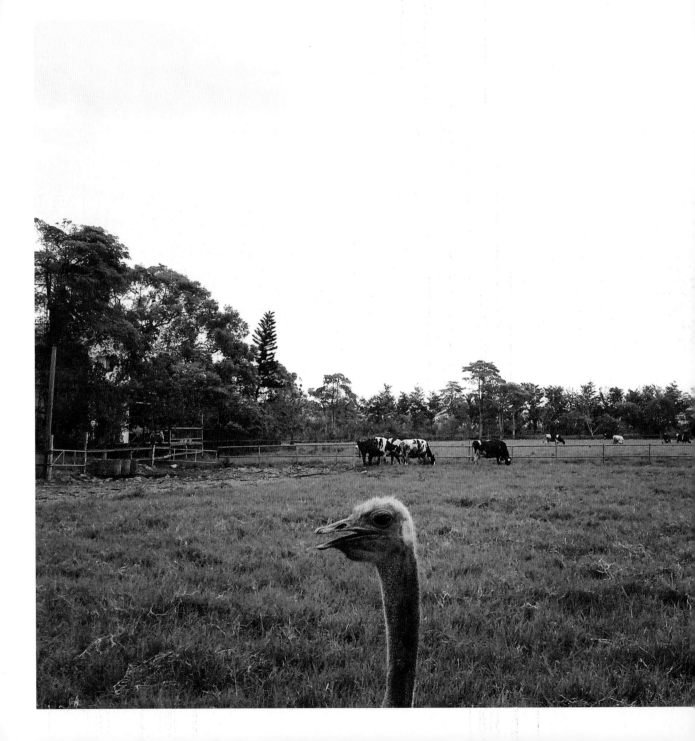

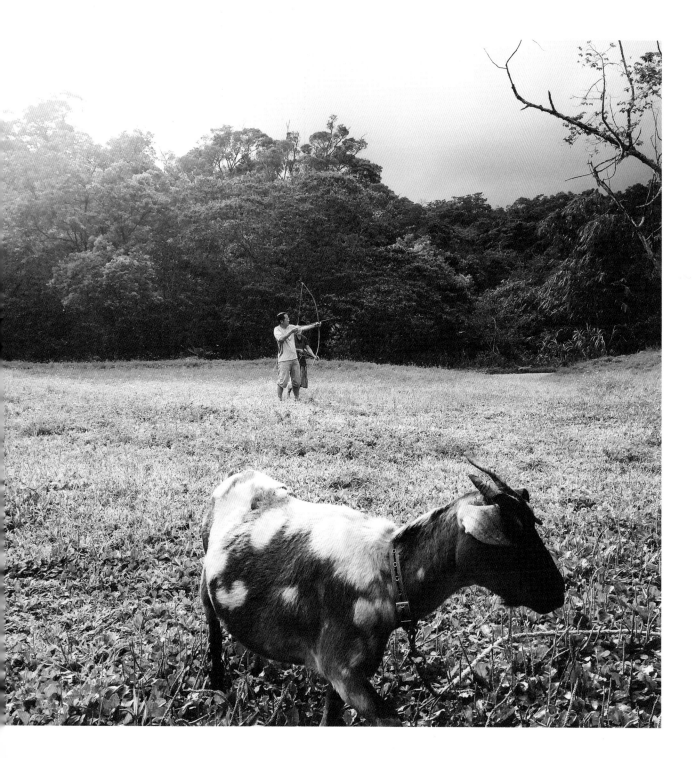

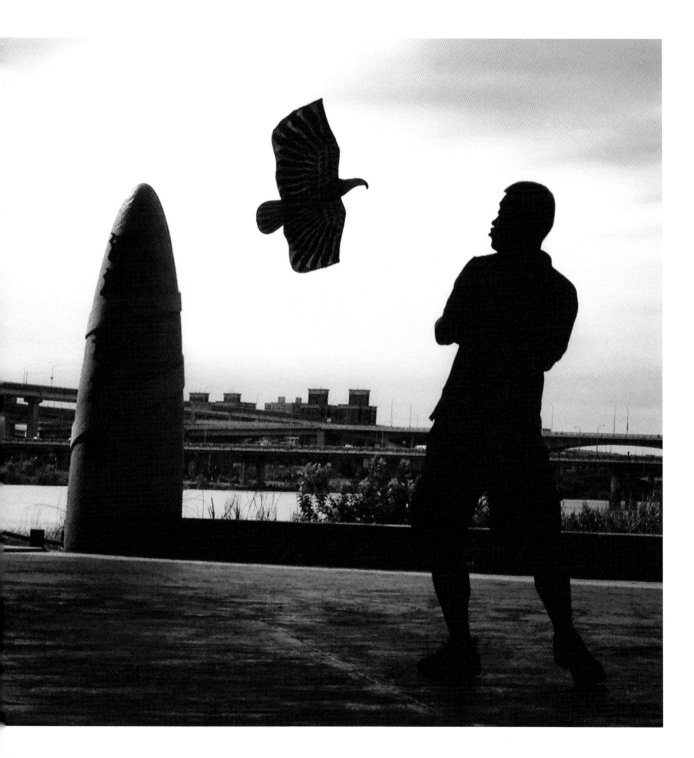

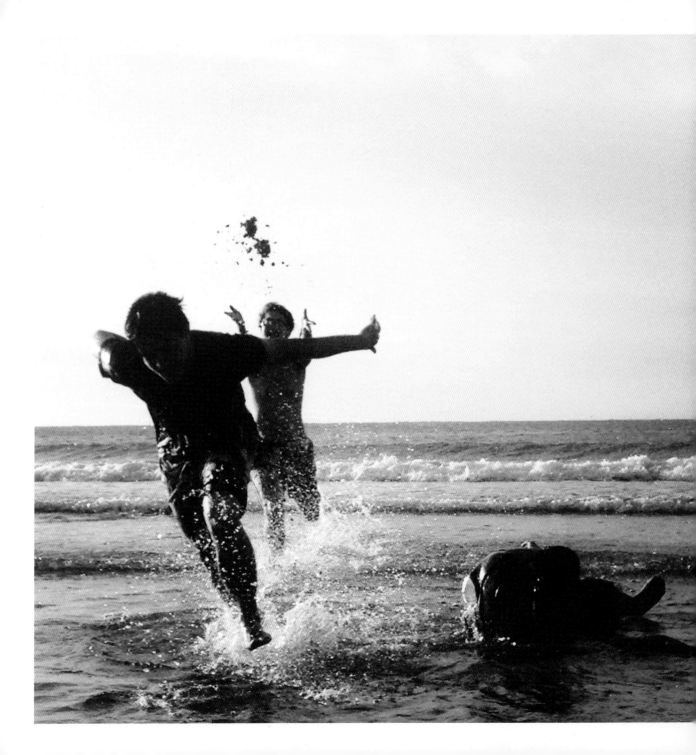

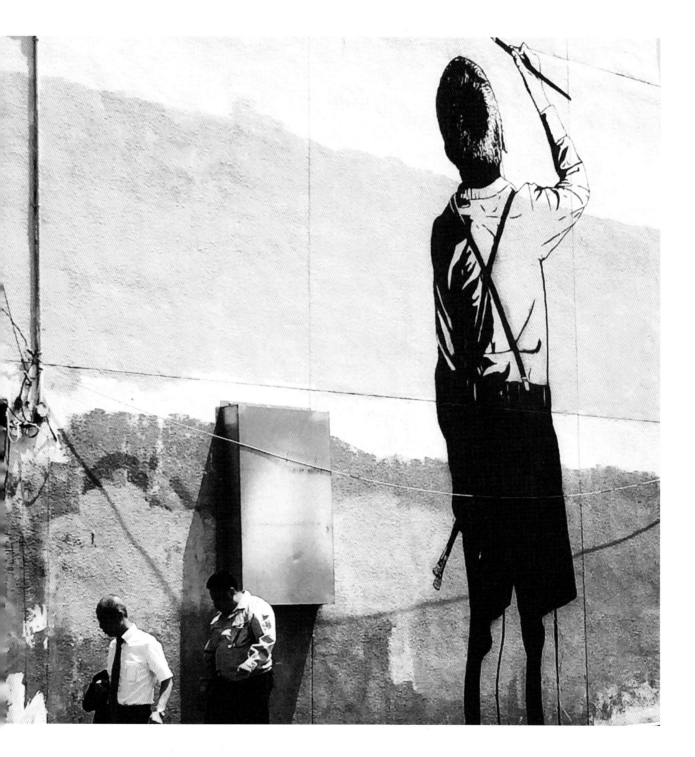

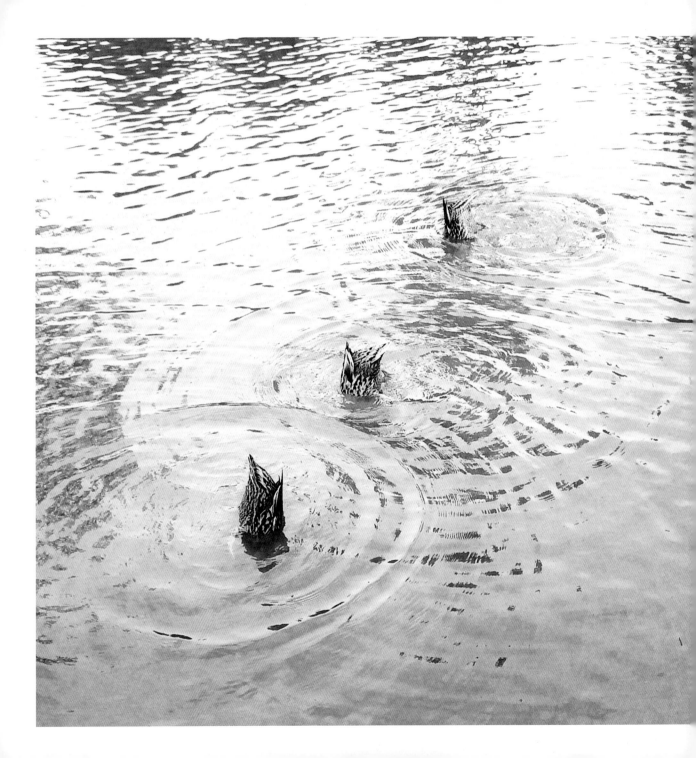

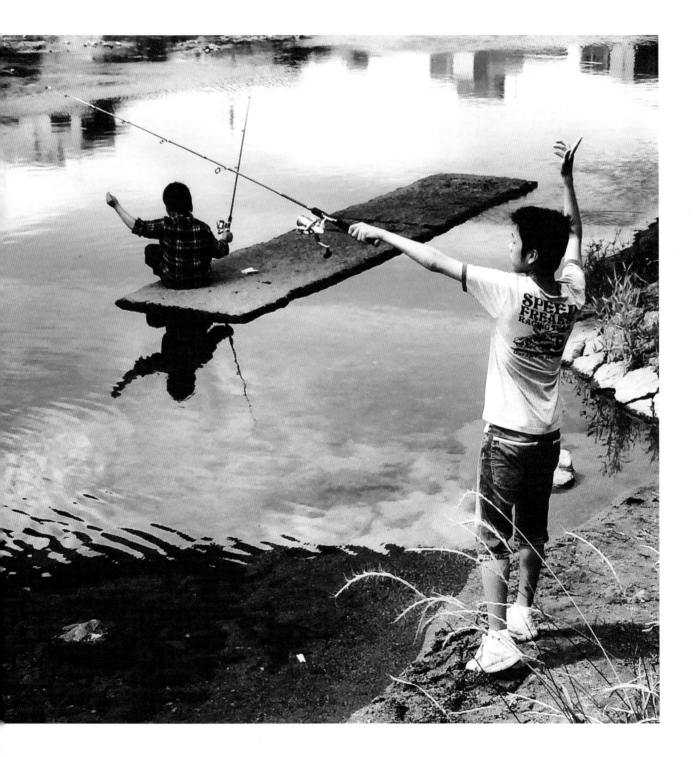

院 喜

HAPPINESS IN A COURTYARD

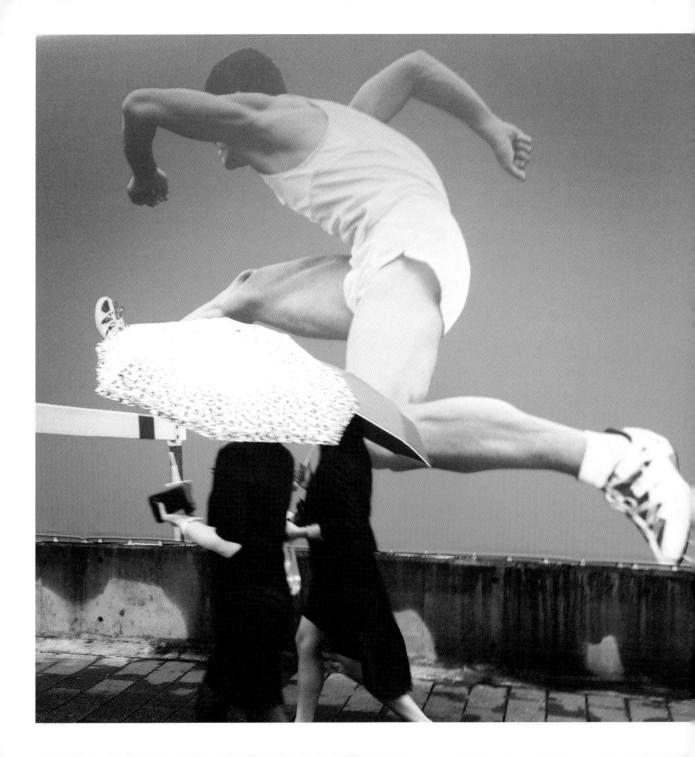

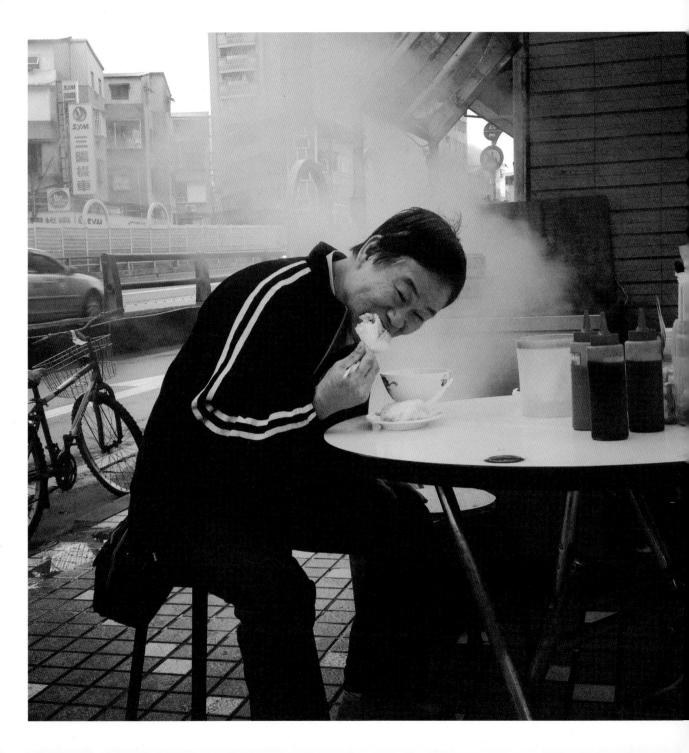

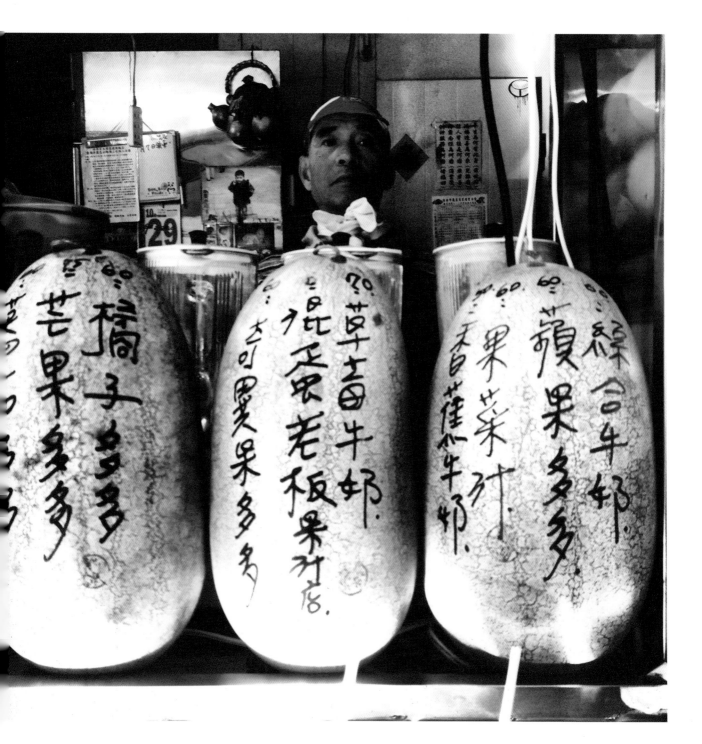

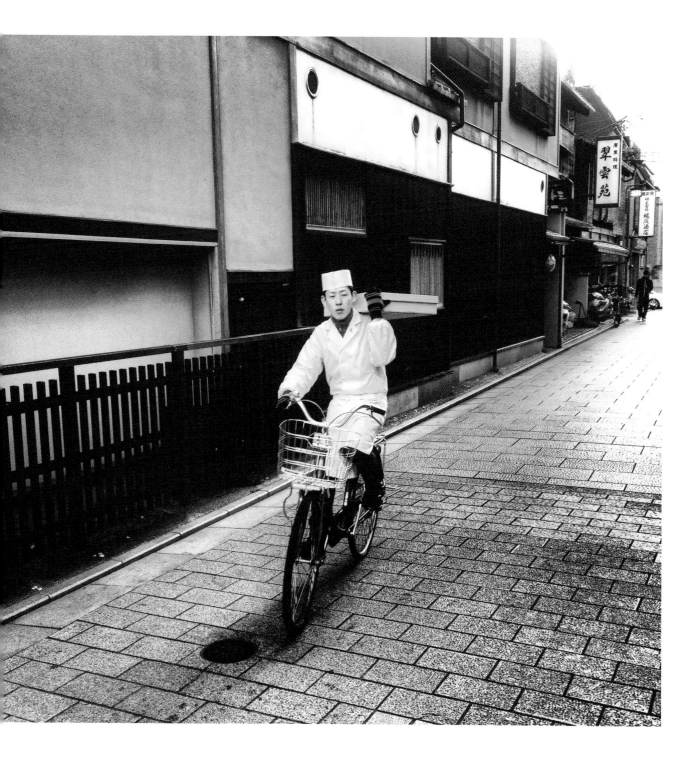

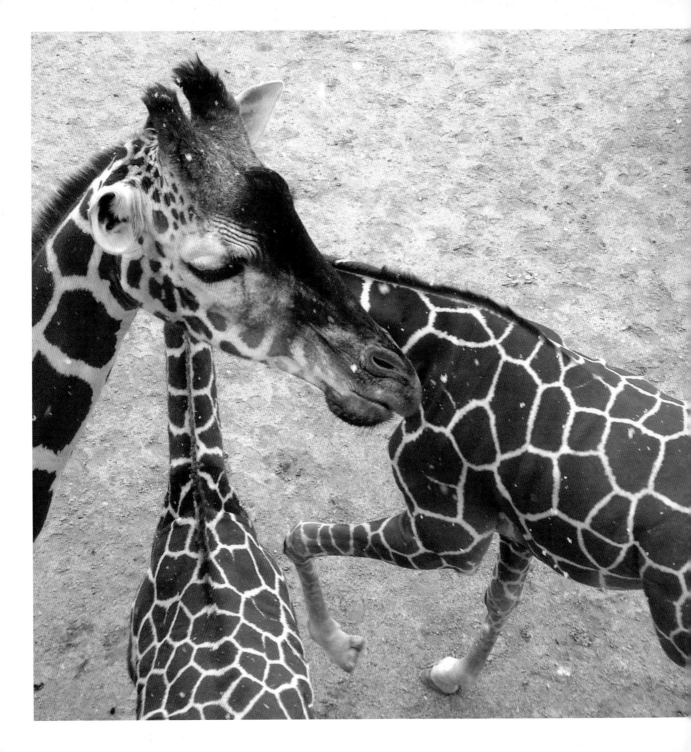

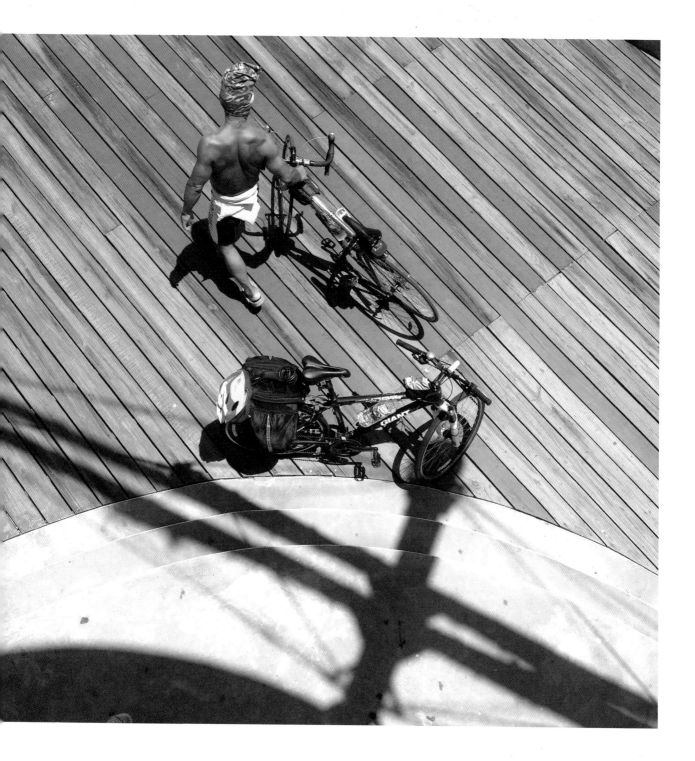

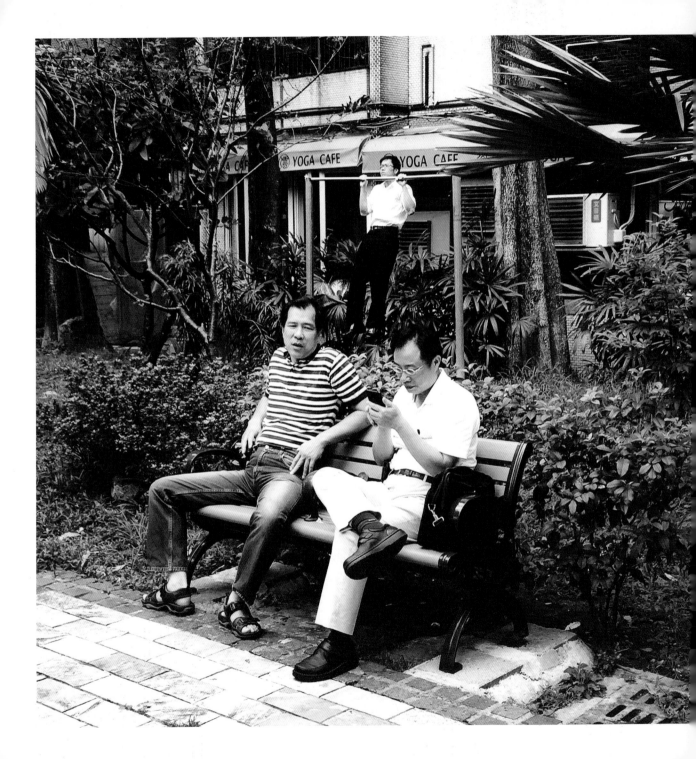

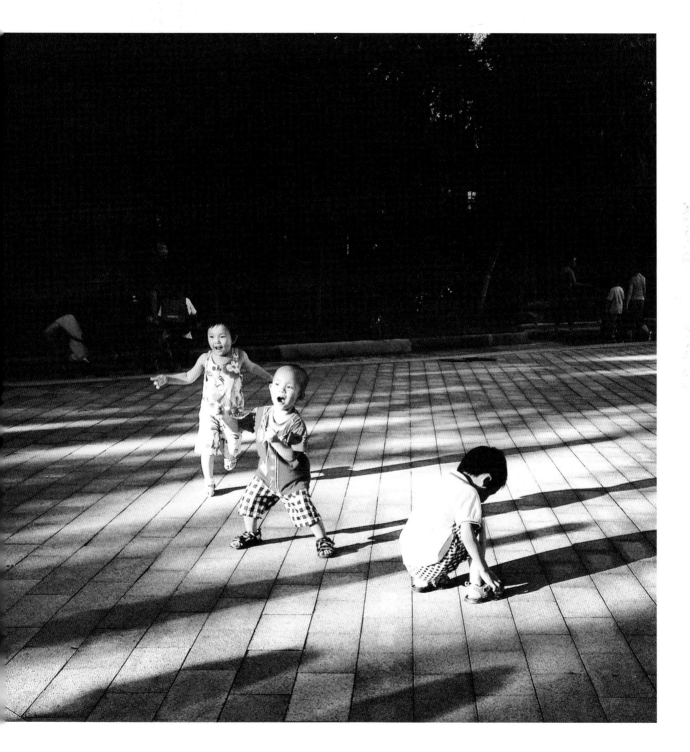

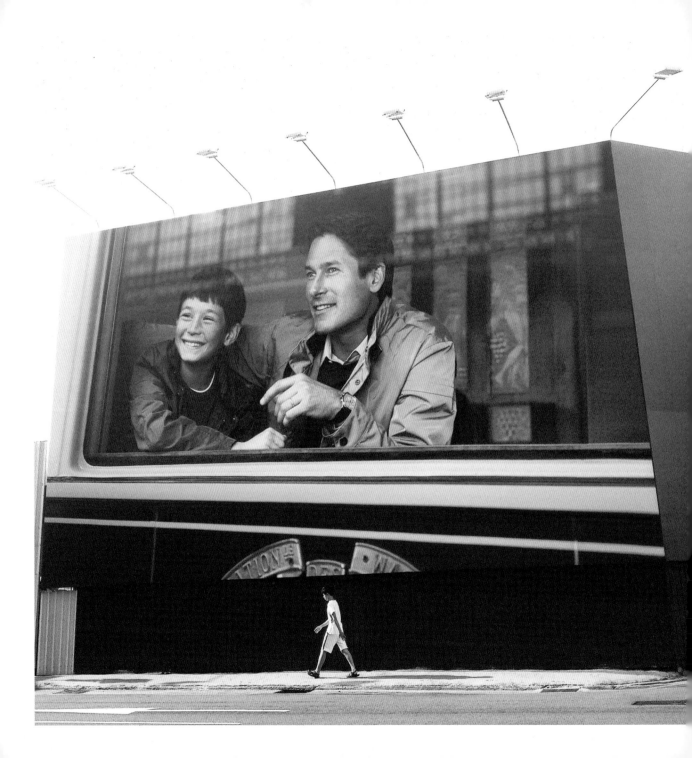

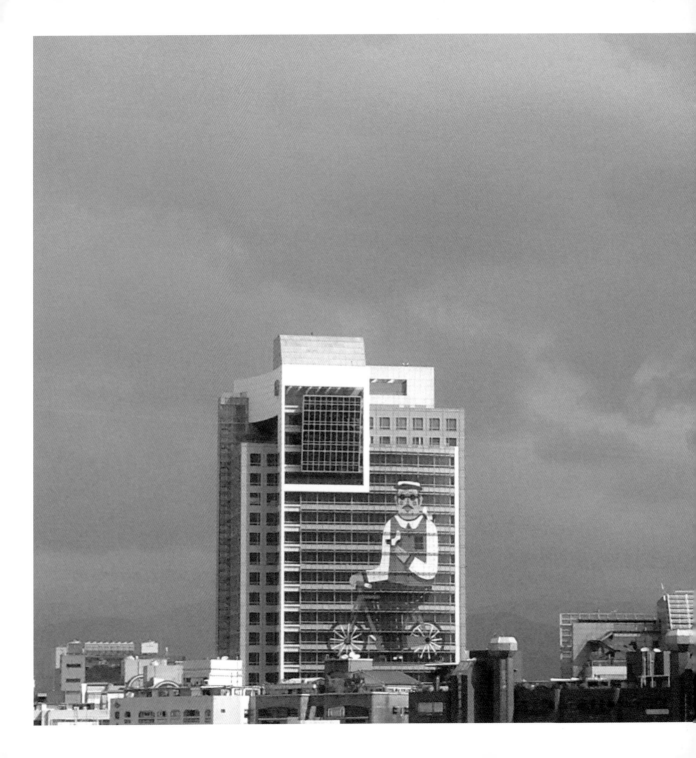

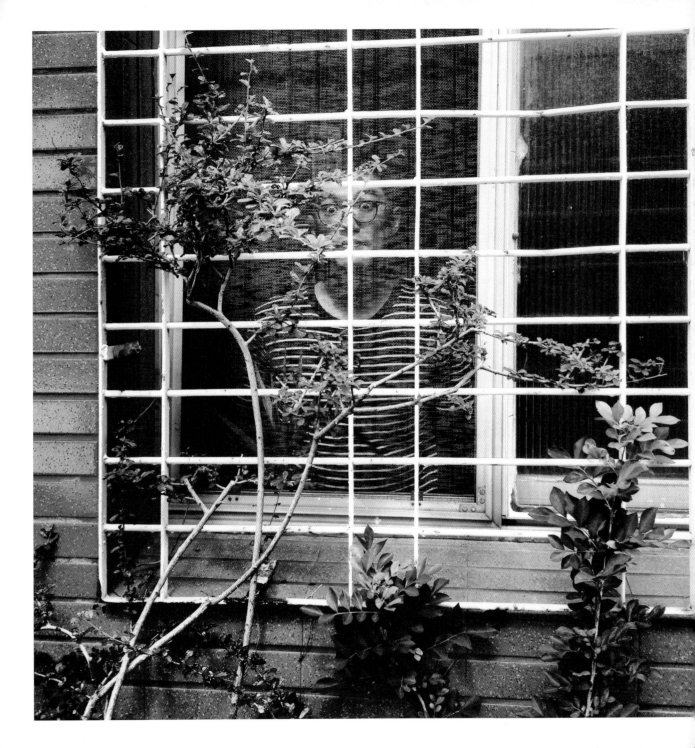

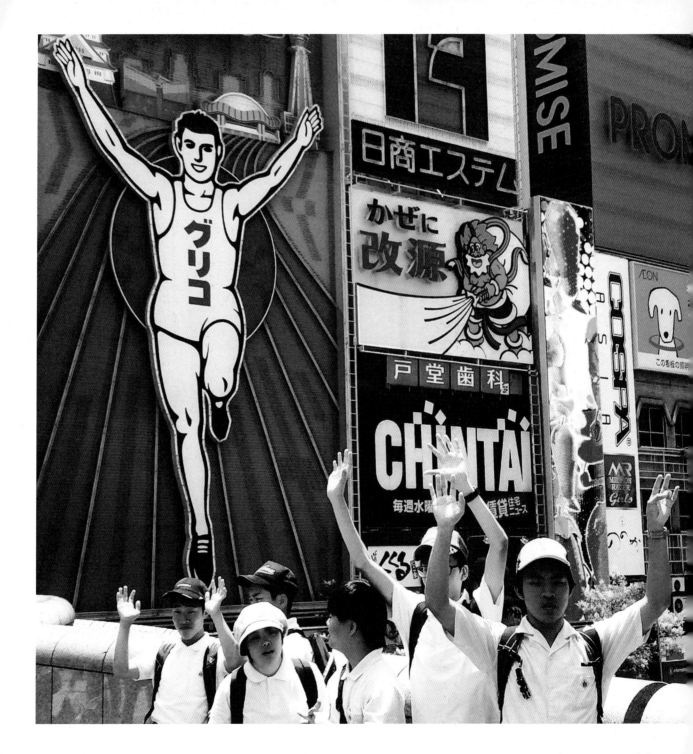

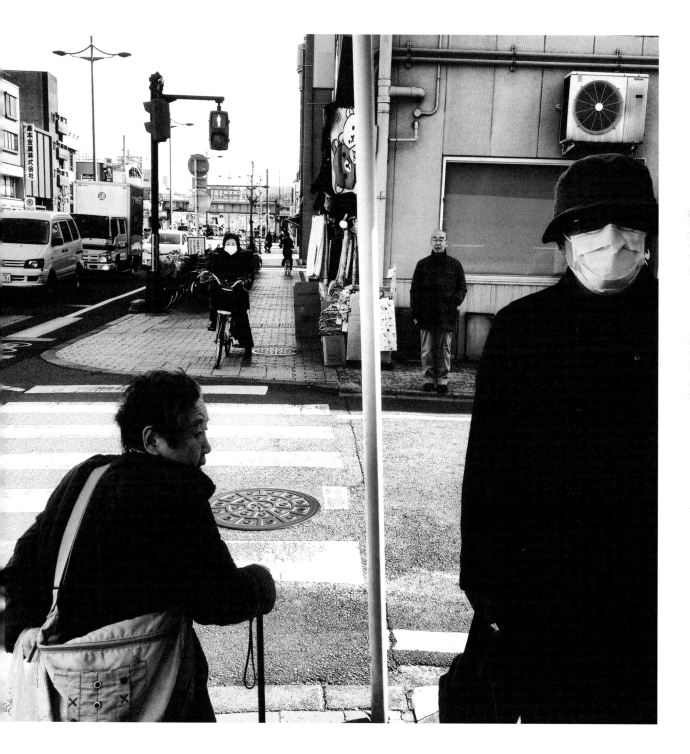

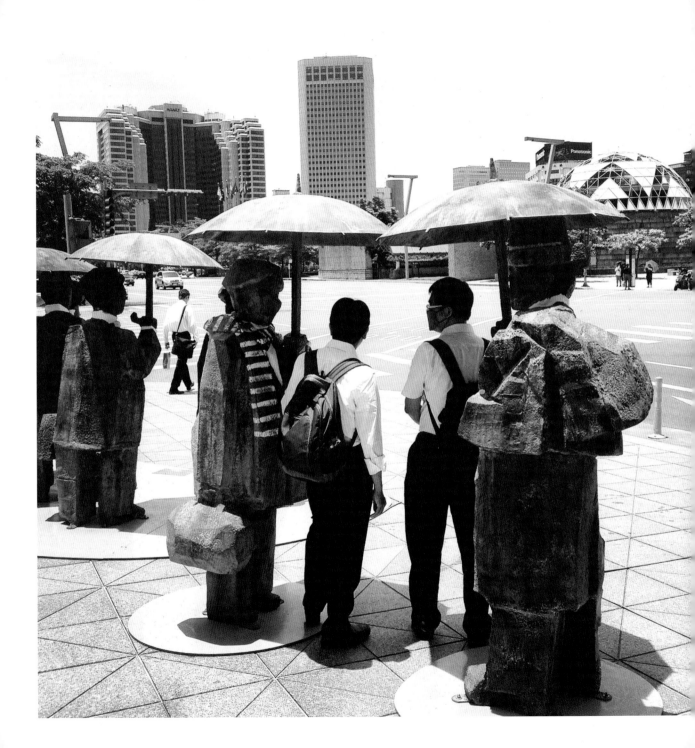

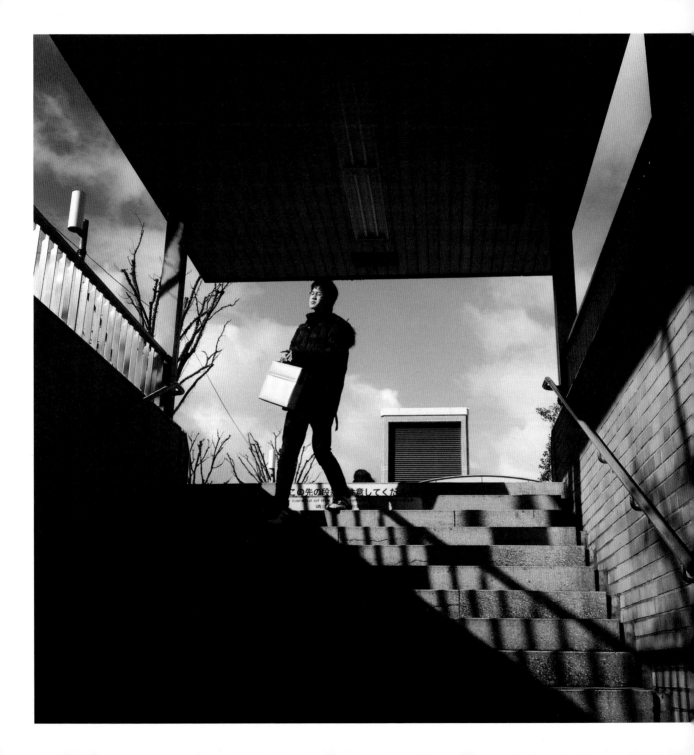

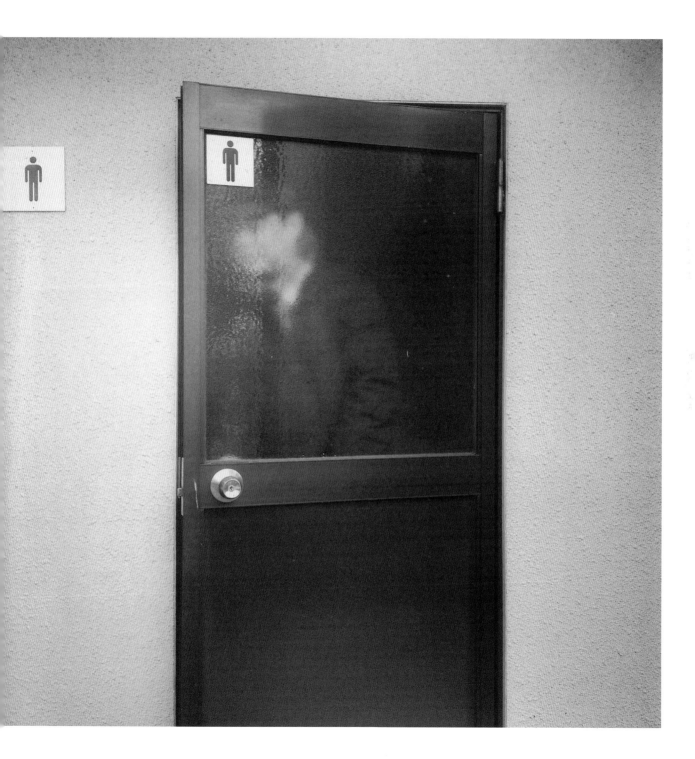

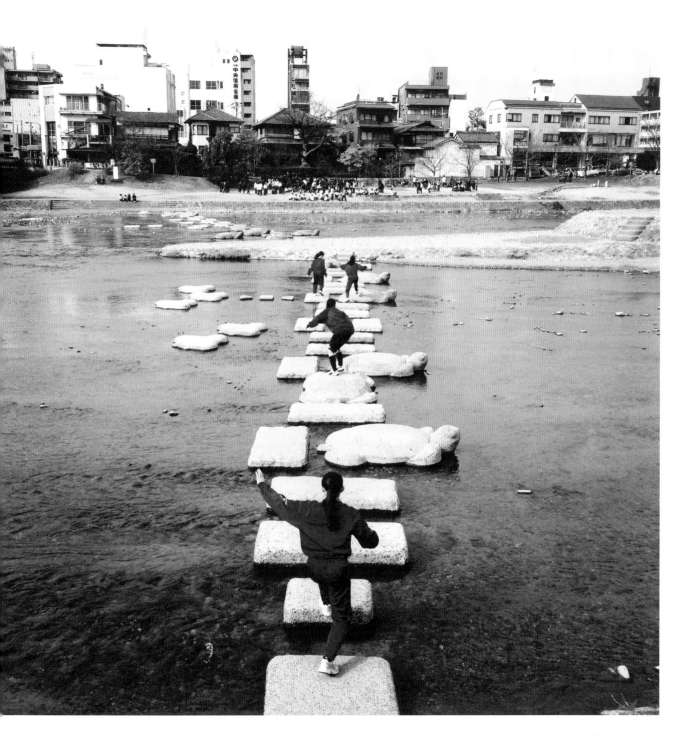

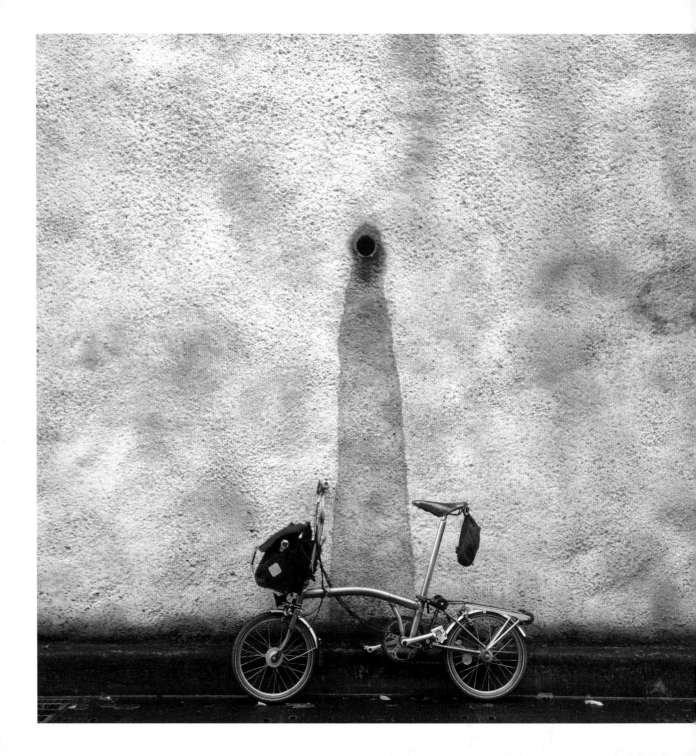

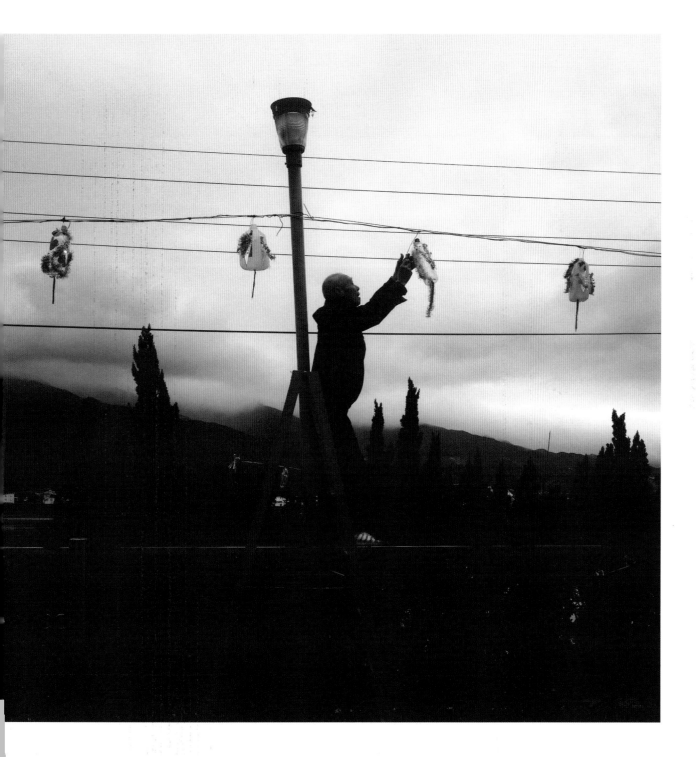

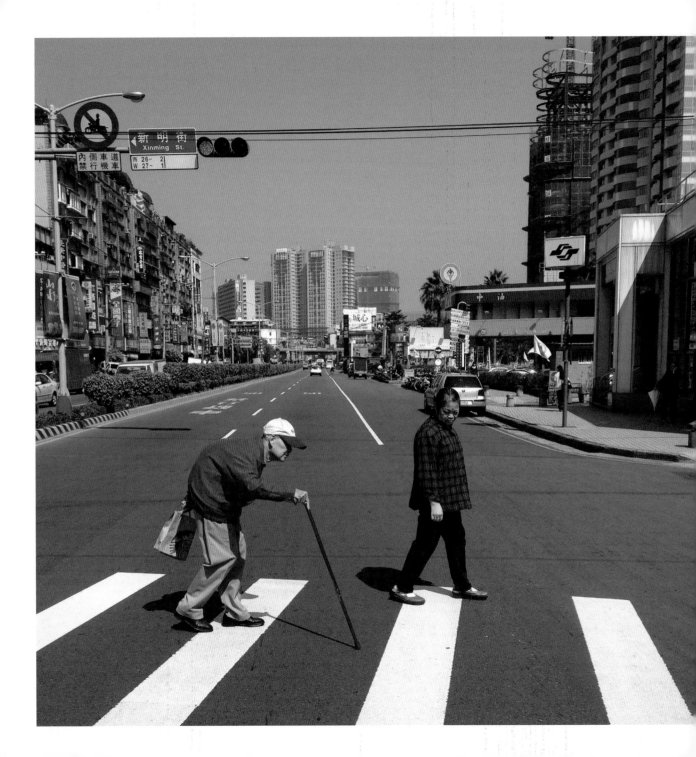

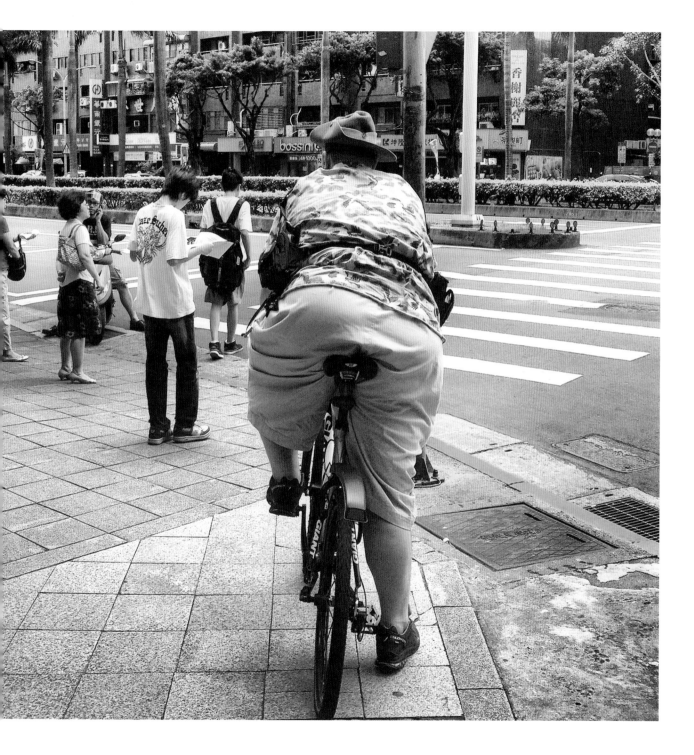

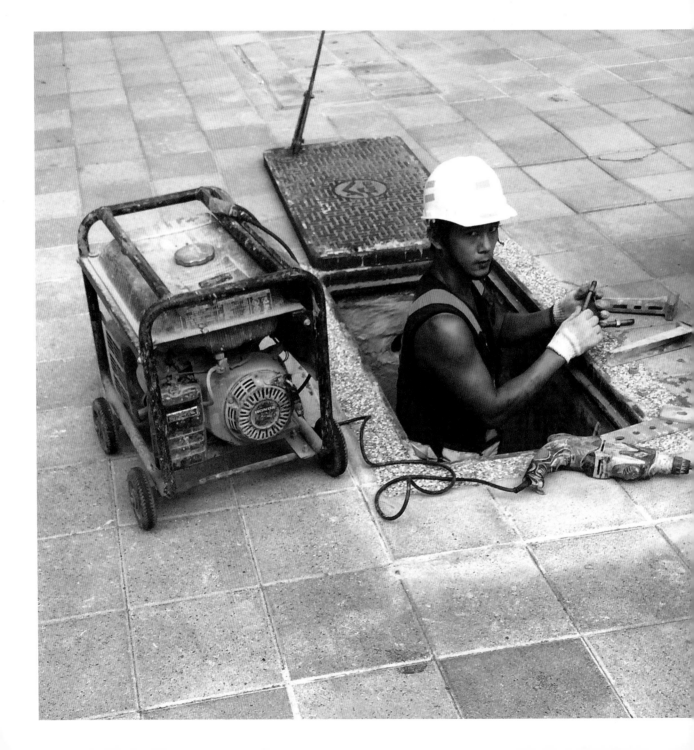

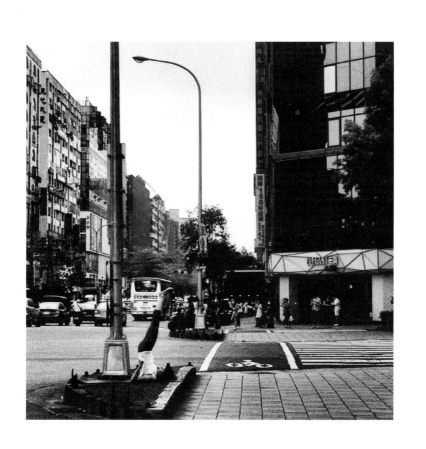

黑文化 Black Issue

黑文化出版台灣文字、設計、攝影等領域新生代創作者之著作，以符合市場品味的實驗性出版品，脫離傳統書籍的行銷脈絡，不流於市場追逐明亮的習性；不做循規蹈矩的書，一如文化習藝的漂流教室，

Black Issue publishs collection of writing by creative young generation in Taiwan with its fulfuilled market demand yet experimental, independent publication. Instead of reducing itself to the possitivity-obsessed market.

Black Issue challenges the traditional publication marketing conventions; it is like a drifting classroom dedicates to the cultural and art which make books that break rules.

空白地區統籌策劃
Planned by Empty Quarter workshop

www.empty-quarter.net www.facebook.com/fis.workshop

可口智造 cacao intelligence

這是一本關於夢想與挫敗、絕望與勇氣的革命通訊。這是一本談論
人、知識以及趨勢的紮實讀本。這是一本提供未來世代創意養份的超效
食譜。每一期，我們介紹一個主題、一座城市，以及創意人物。每一
期，我們針對主題探討核心概念。每一期，我們獨家呈現無國界創意人
士的熱燙觀點。

《cacao可口》季刊．中英對照．台灣出版，瑞典、中國、香港、柏林發行。

This is a revolutionary newsletter about dream and frustration, about depression and
courage. This is a solid book about people, knowledge and trend. This is a wow recipe
for the future generation to get creative nutrition.

In every issue, we introduce a theme, a city and twelve creative people. In every issue,
we invite academic and professional talents from different fields to talk about the
theme. In every issue, we present beautiful viewpoints of people from creative
industry, from every corner of the world.

Quarterly Issue. Texts in Chinese and English.
Edited and Published in Taiwan, distributed in Sweden, China, Hong Kong and Berlin.

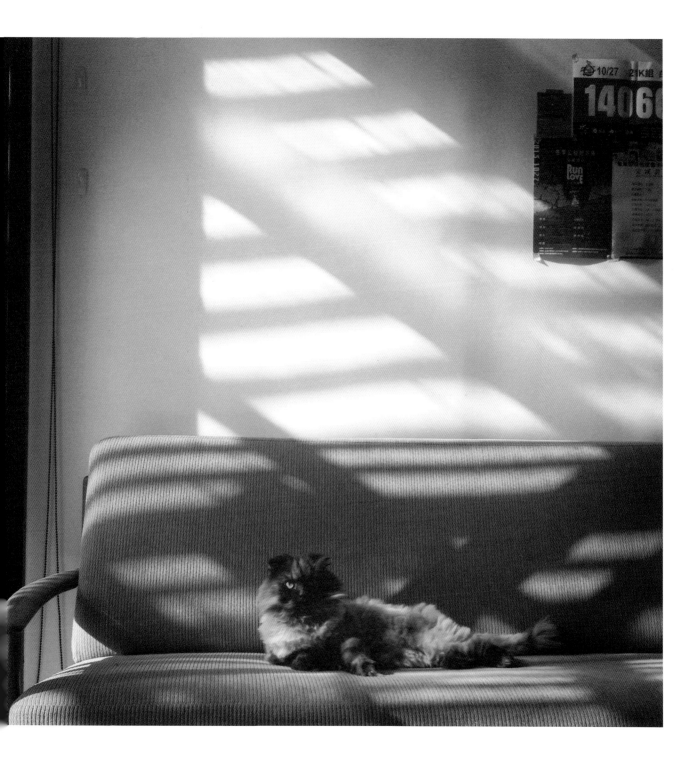

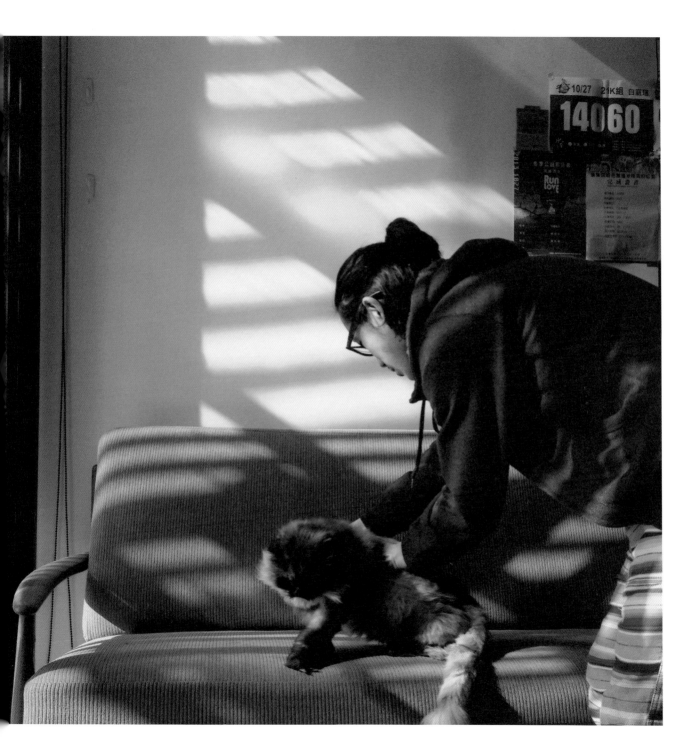

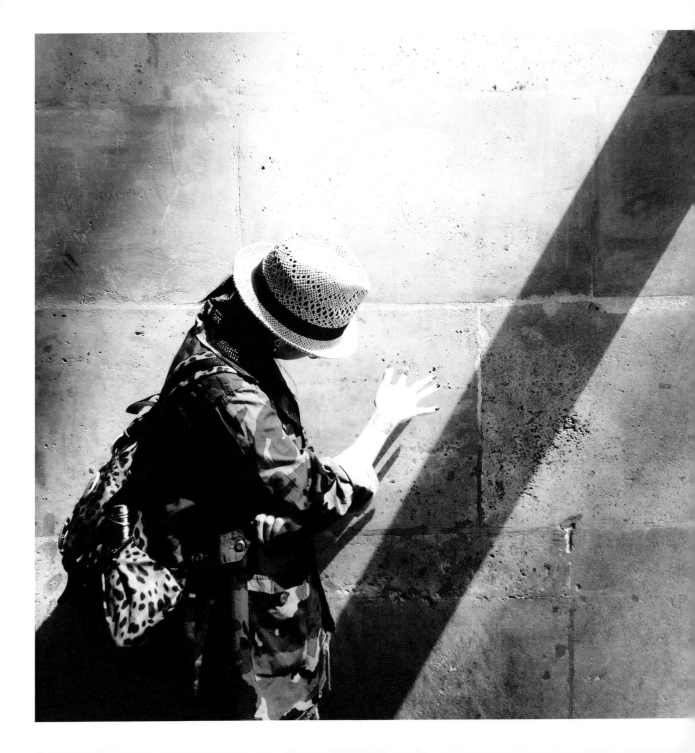

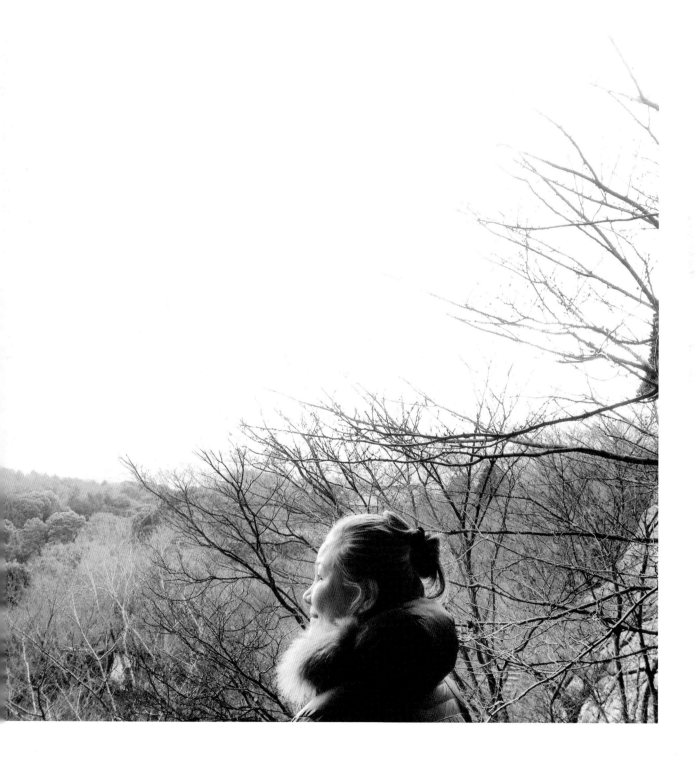

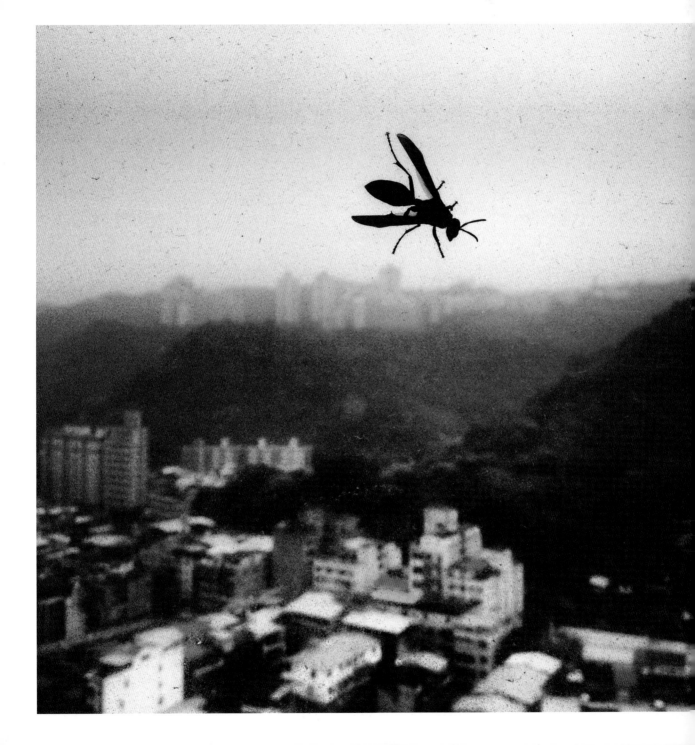

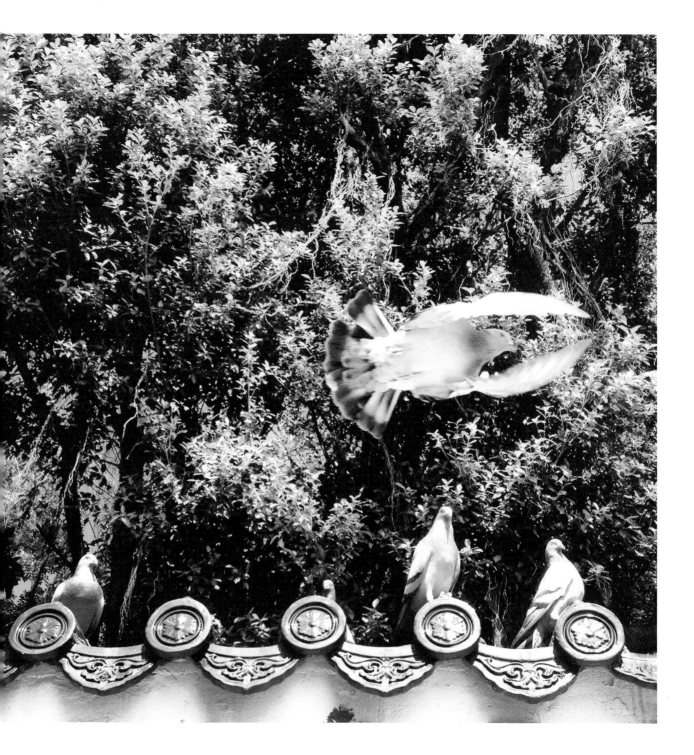

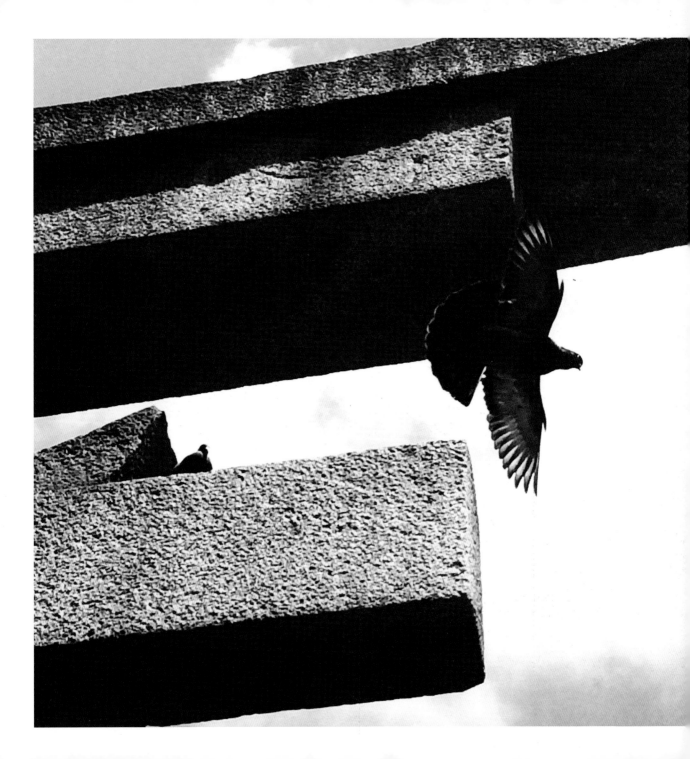

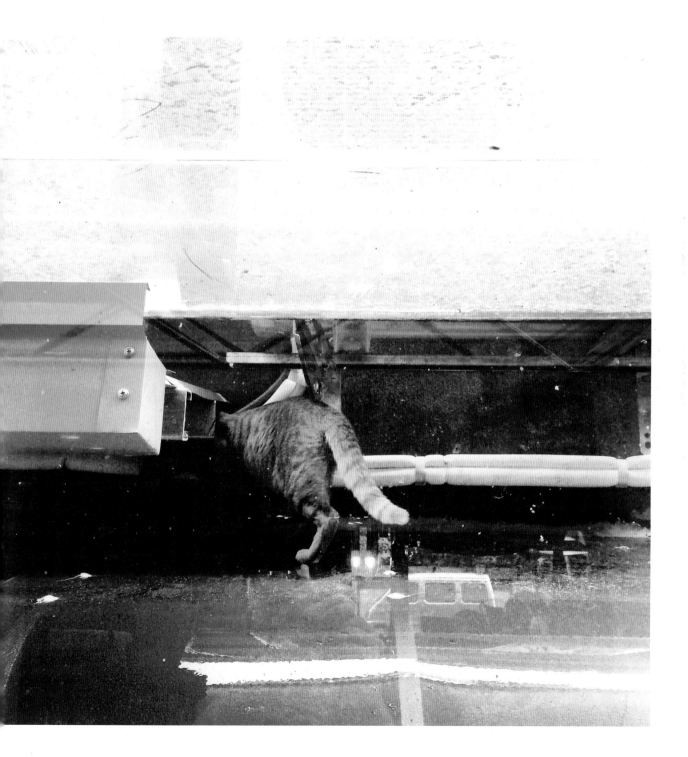

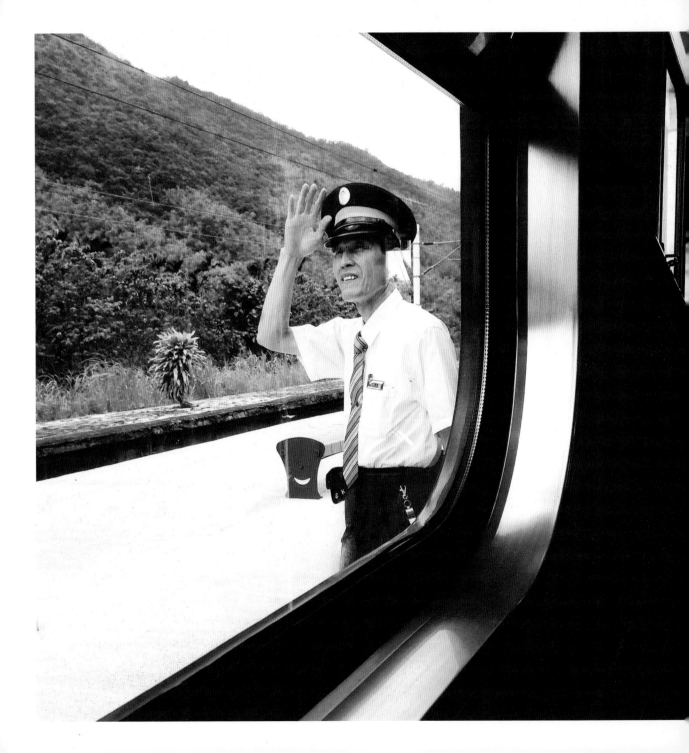

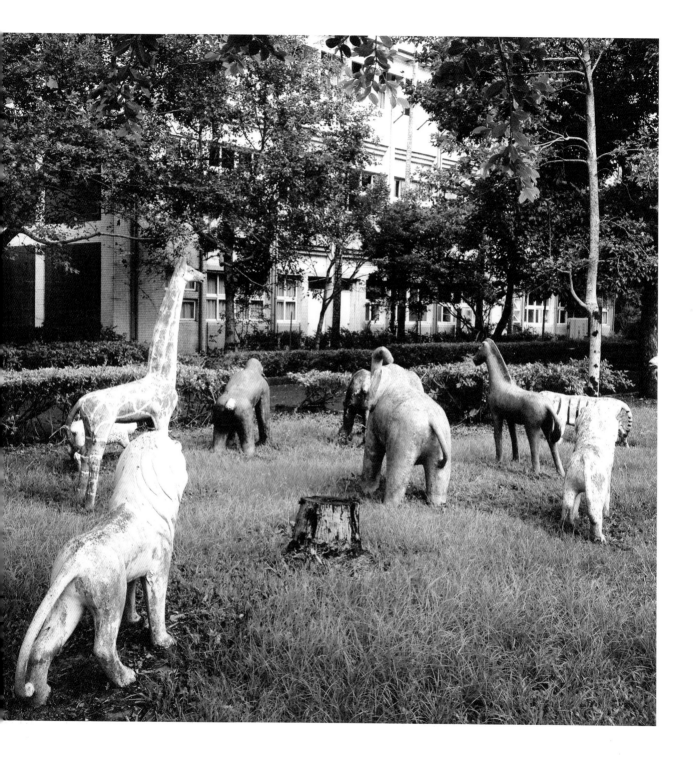

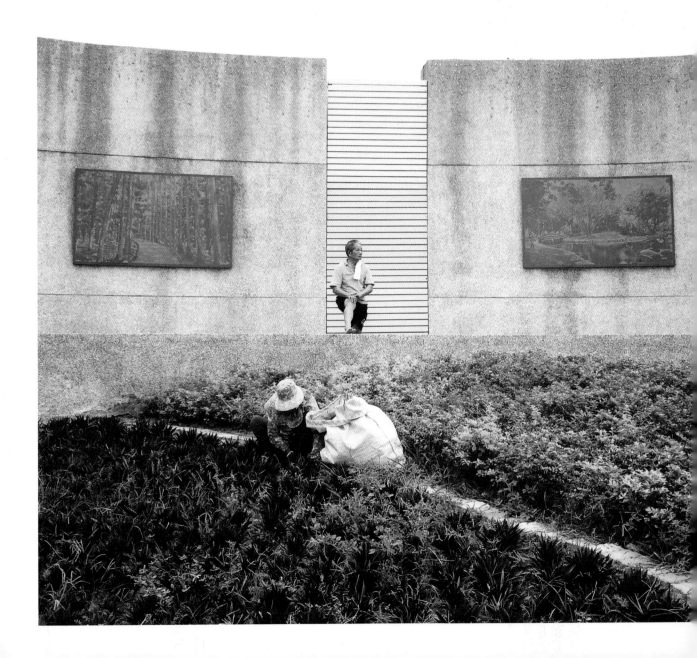

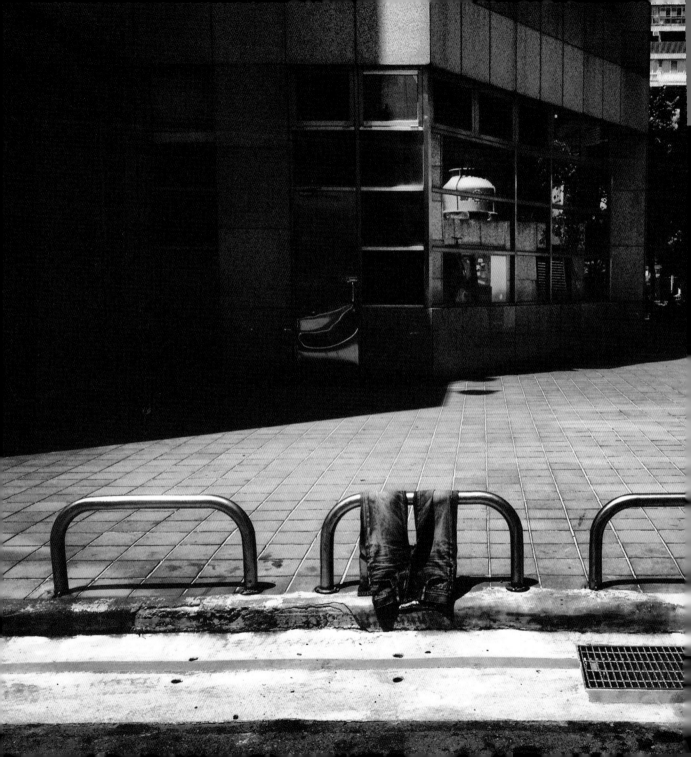

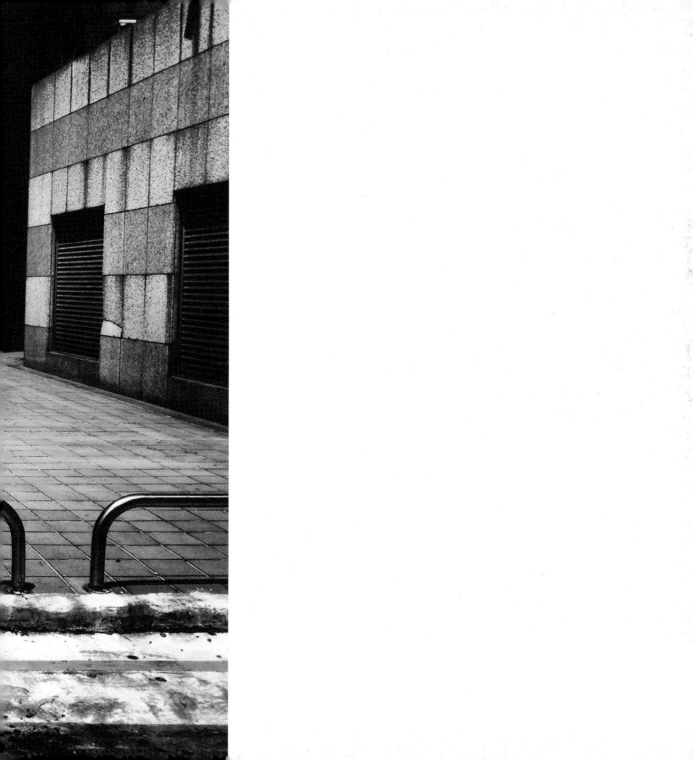

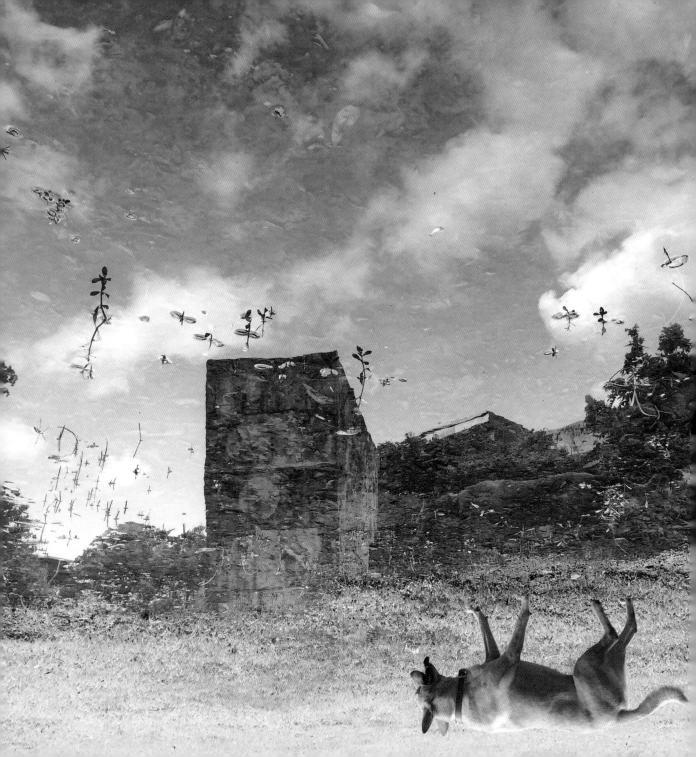

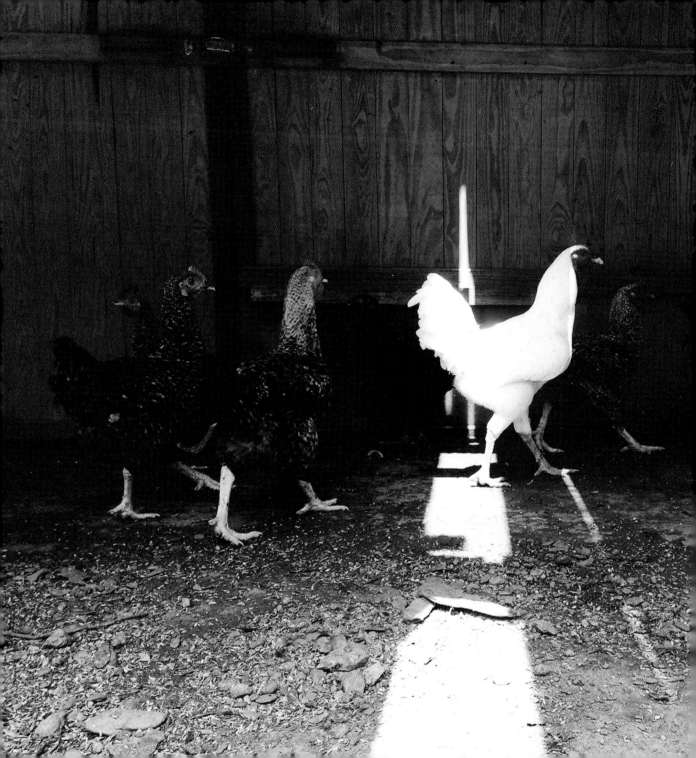

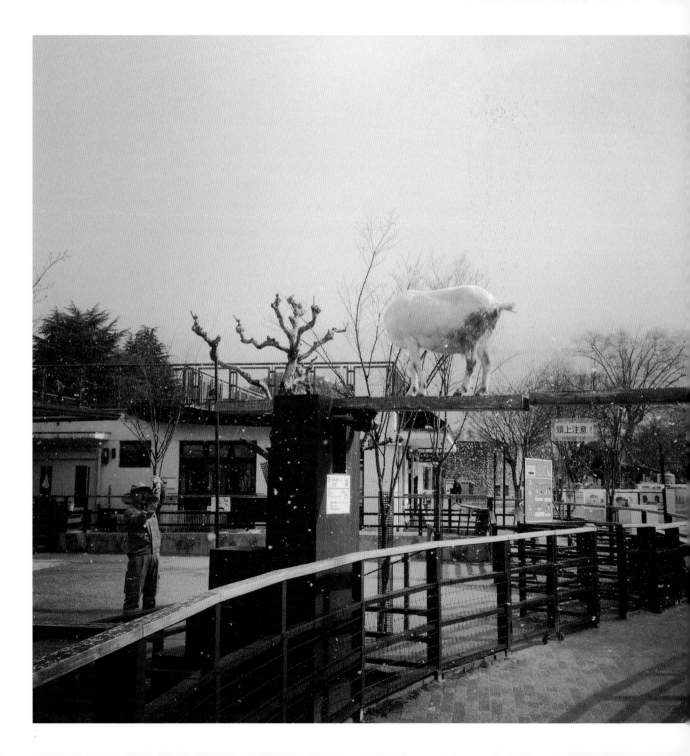

我可能是阮璽所認識的人當中，最後一個知道他在拍照的。身為他的父親，我一直勸他不要碰攝影，因為壓力會太大；我也以為他不會在藝術領域發展，他從小討人喜歡、得人信賴，最適合從事公關或業務推廣。

記得他在讀大學時，有一回很慎重地給我看他的畫。我翻了幾張，跟他說：「這還只是塗鴉，任何人在空想時，拿支筆都能畫得出來。你如果想表達心中的感覺，就要好好練基本功，從觀察開始，把眼睛所見用手勾勒出來。能夠把看到的畫真，才能把想到的畫美。你別看老爸的插圖只是隨意幾根粗細不等的線條，背後其實是從小按部就班的苦練。」

那席話很可能澆熄了阮璽的繪畫熱情，但幸好沒阻擋他對美與藝術的追求。父子倆各有所愛，我那大量的藏書與黑膠唱片他很少去翻，在這方面極少受我影響。他自己買喜歡的書和音樂，穿的、用的更是跟我不同路。他對好設計品特別感興趣，而且喜歡跟人分享。熱愛蘋果電腦，便找了個銷售工作，還收集該品牌各個時期的原型；喜歡丹麥、瑞典的傢俱，便當起了二手北歐傢俱店的店長。

從小我對阮璽便沒什麼特殊要求，只希望他健康、快樂，告訴他要做一個誠實的好人，忠於自己、善待別人，能這樣，一輩子就算沒白過。他在當電腦業務員時，有一天我跟他母親去百貨公司的專櫃找他，工作環境讓我看了嚇一跳，很難想像在那麼吵雜、窄小的空間站一整天、吃兩個便當是什麼滋味。用餐、上洗手間還得抓緊空檔，趁沒客人時盡快解決。那時我才曉

Among all of his acquaintances, I may have been one of the last to know about Juan Sea's photography. As his father, I often told him not to enter the photography industry because the pressures are enormous. I also thought that he wasn't suited to a career in the arts. He was lovable and well trusted as a child, someone I thought would be better suited to public relations or sales jobs.

When he was in college, I remember him once carefully showing me his drawings. I browsed through several of them and told him, "These are only doodles. Anyone can draw these with a brush in their hands when they are daydreaming. If you want to express the feelings in your heart, you'll need to practice the basic skills: first carefully observe and then draw what you see. When you can realistically depict what you see, only then can you draw something beautiful from your imagination. When you see my drawings, they may seem to only be a few simple, random lines, but what you don't see is all the hard work I've invested over the years." These words may have destroyed Juan Sea's passion for drawing, but fortunately it didn't stop his pursuit of art and beauty. We have different interests. My book and record collection doesn't interest him and in this area I didn't significantly influence him. He buys books and music he likes, and his style and tastes in what he wears and uses is very different than mine. He has a special enthusiasm for well-designed products, and he loves sharing this with others. For example, he loves Apple computers so much that he took an Apple sales job and has collected prototypes from the different Apple computer eras. He likes the design of furniture from Denmark and Sweden so much that he managed a second-hand Scandinavian furniture store.

I didn't insist on many things with Juan Sea when he was young; my primary hopes being that he would be healthy and happy. I told him, "Be an honest, kind man, be loyal to yourself, and treat others well. Do this, you will have lived a fulfilling life." When his mother and I visited him at the mall store where he worked as a computer salesman, the work environment surprised me. It was hard for me to imagine spending all

得，他吃得起苦，為了喜歡的事，可以克服環境，把苦變樂，這還真是天生樂觀的人才辦得到。

大概是因為我比較嚴屬，阮璽基本上很少跟我談學業、服役、或工作的情況，有事只會跟他母親說。每次問他：「最近怎麼樣？」他的回答總不外乎「還好」、「可以」、「OK」，讓我難以分辨其中的差別。他也一直沒讓我知道他在拍照，直到有一天，說要帶我和他母親去一間他所吃過最棒的臭豆腐店。

那一帶我已多年沒興趣前往，況且住家附近就有一攤難得好吃的臭豆腐，酥炸、麻辣任人挑，想不出臺北有哪家會勝過。不過，他的好意讓我非常開心，即使是不怎麼樣，也無妨。

果真不怎麼樣，可是，吃完他又說了：「附近有家我朋友開的咖啡館很不錯，要不要去坐坐？」這我就更不以為然了，多年來我只喝自己烘焙的咖啡，但依舊覺得開心，而且他母親興頭特別大。

果然又不怎麼樣，而且竟不供應搭配的甜點！我特地去附近便利商店買了一包巧克力，回到座位時只見他母子倆頭靠著頭在看些什麼。坐定，老伴才說：「兒子拍了些照片，你幫他看看，給點意見。」這時我才恍然大悟，原來，阮璽記取了多年前的教訓，費心安排，希望我在比較輕鬆、愉快的心情之下看他的作品。

day, including two meals, standing in a place so noisy and confined, even needing to wait until there were no customers to use the restroom or have lunch. I realized then that he was not afraid of hard work and that he could conquer difficulties and turn obstacles into joy for things he's passionate about. Only those gifted with optimism have that ability.

Juan Sea mostly talks about the events of his daily life – his school, military, or work experiences – with his mother. He rarely talks to me about these things, likely because I'm a more serious person. Each time I ask him "How have you been lately?" he invariably answers, "Ok." "So-so." or "Not bad." It's hard for me to distinguish between these answers. He also didn't tell me he was taking photographs until the day he invited his mother and I to what he said was "the best chòu dòufu eatery I've ever been to." I hadn't been to that area of Taipei in many years, and there's actually a very good chòu dòufu eatery near our home, one that offers a choice of fried or spicy chòu dòufu. I can't imagine there's a better one in Taipei. Nevertheless, his invitation made me quite happy and I wasn't concerned with whether the eatery would be good or not.

Just as I expected, the food was nothing special, but after we finished he said, "My friend has a coffee shop nearby, would you like to go?" For many years I've only drunk coffee from beans I've roasted myself so I didn't have high expectations for the coffee. Nevertheless, I was happy he invited us and his mother also seemed quite excited to go.

Again, just as I expected, the coffee was nothing special. Moreover, I wasn't even able to have dessert because they were sold out; I instead needed to go to a convenience store to get a package of chocolate. When I came back to the cafe, I noticed he and his mother looking at something together. When I sat down, my wife said, "Your son took some photos. Why don't you take a look and give him your opinion." At

一看之下，不得不說「好！」。所有照片都是他用手中那台iPhone拍的，而且沒整理出來給我看的還很多。原來他幾乎天天拍照，已拍了快兩年。我這也才明白，他每天騎著那輛拉風的英國手工打造摺疊式腳踏車上下班，是在幹嘛，為的就是能在大街小巷穿梭、拍照。

我拍照超過四十年，寫過兩本介紹世界攝影大師及新銳的書，辦過十多年國際性的攝影雜誌，在大學教了二十五年攝影，閱歷算豐富了，但阮璽的作品讓我充滿了觀看的新鮮感，每張照片都躍出一種生氣勃勃的熱情。臺北的大街小巷，處處向他展現著活潑、幽默的一面，平凡事物在他的鏡頭下顯得活力十足。

攝影自有史以來，幽默的視角就比較少見；紀實攝影趨於沈重，觀念攝影則不是太冷感就是過度自憐。阮璽所拍的照片充滿溫度，構圖又嚴謹，實在是讓我意外。我從前勸他不要走攝影這條路，擔心他會籠罩在父輩的陰影之下，現在看來，我是多慮了。如今我倒是樂意聽到有人說：「你兒子拍得比你好！」

阮璽的所有作品都是用手機拍的，手機攝影的方便使許多人的創作態度改變，依靠軟件求取特殊效果，在取景時誇大前景深、故意不經意地框取特寫，藉以表現純圖像的趣味；結果，卻讓人愈看愈沒感覺。攝影最特別的地方，就是會表現出攝者與被攝者之間的微妙關係。本來毫無淵源，但在快門按下的那一剎那，就彷彿有了血緣。阮璽在街頭拍了許多擦身而過的

this point it occurred to me that Juan Sea had carefully arranged things so I would see his work the first time in a relaxed and happy state of mind, likely because of the lesson he had learned years ago when he showed me his drawings.

My first impression was, "Awesome!" All the photos were taken with his iPhone and beyond those he showed us, he had many more we didn't see because he had not yet organized them. I then understood that the reason he rode his fancy, hand-made, foldable British bike to work was so he could take pictures as he cycles the streets and alleys of the city. I've been taking photos over 40 years. I've written two books about world-famous photographers, I founded an international photography magazine that was in print for over a decade, and I taught photography in university for 25 years, so I think I'm quite experienced in the field. Yet when I see Juan Sea's work I feel refreshed: each photo is vibrant and lively. The Taipei streets show him their playful, humorous side and ordinary settings seem vivid and energized through his lens.

Since it's emergence, photography has seldom been humorous. Documentary photography is typically weighty while conceptual photography is either too cold or too self-pitying. Juan Sea's photographs surprise me with their warmth and structural composition. I used to tell him to not become a photographer because I was worried he wouldn't emerge from my shadow. It would now seem that I was overthinking. Today I would be happy to hear someone say, "Your son takes better pictures than you!"

All of Juan Sea's works are taken by cell phone. The convenience of a phone camera changes the way people take pictures. They use software to get special effects, use depth of field dramatically, or intentionally stage a close-up to seem inadvertent, attempting to show something interesting, but the resulting images are bland. What makes photography special is that a photograph captures the moment a relationship

人，他們的側身或背影傳達了與空間組成的一種特殊氛圍，故事性很強，彷彿是影像小說的極短篇；他也愛拍動物，無論禽鳥、狗、或貓，都帶著令人莞爾的靈性，生動而喜氣，溫暖又令人回味。

我與阮璽相處最密切的時光，是在寫《當代攝影大師》、《當代攝影新銳》以及籌備《人與土地》展覽的那陣子。當時他讀幼稚園，不想上課，整天跟著我。那兩本書原是《雄獅美術》的專欄，每個月得交一篇。我總是坐在臺北民生東路巷內的「芳鄰餐廳」，在同一張桌上從白天寫到晚上，直到他母親下班來會合。給他幾張紙、一支筆，他就乖乖地坐在旁邊塗鴉，畫累了就自己跑到隔壁的公園玩耍。

籌備《人與土地》展覽時，他是第一個觀眾。我將所有照片在一座25:1的展場模型上擺來擺去，他問：「為什麼要分成四個單元？『成長、勞動、信仰、歸宿』是什麼意思？」我一一說明，但實在不曉得如何對小孩解釋「信仰」，只有這麼回答：「無論發生什麼事，爸爸媽媽都是愛你的，而你也會愛爸爸媽媽。永遠不變的愛，就是信仰。」當時他似懂非懂地點頭。二十七年後的今天，他不但要開個展，還要出版攝影集。這讓我明白，我的話他聽進去了。現在，我只希望阮璽和我一樣，把攝影也當成信仰。

文·攝影家 / **阮義忠**

begins between the photographer and his subject. They were unrelated, but become connected the moment the shutter is clicked. Juan Sea takes many pictures of passersby: their profile or back and the surrounding space create a unique ambiance and a narrative as compelling as a short film. He also loves taking pictures of animals, regardless of whether they are birds, dogs or cats. You smile at the warmth of their spirit and the picture's vivid joyfulness lingers in your memory.

While I was writing "Contemporary Photography Master" and "Young Talent of Contemporary Photography" and preparing for my "Man and Land" exhibition, Juan Sea and I spent most of our time together. He was in kindergarten at the time, and didn't like to go to school, so he stayed with me all day. Those two books were compilations of my monthly columns for "Lion Art" magazine. I always wrote in a restaurant called "Fan Ling" at Mingshen East Rd. in Taipei, sitting at the same table, working from morning to night until his mother got off work and met me there. I'd give him pen and paper and he'd sit beside me doodling. When he tired of this, he'd play in the park next to the restaurant.

When I was preparing the "Man and Land" exhibition by setting up all the pictures in a 25:1 model of the exhibition space, he was my first audience. He asked, "Why are there four different sections? What do 'Growing,' 'Laboring,' 'Faith' and 'Destination' mean?" I explained them one-by-one, but, unsure how to explain faith to a child, I told him, "No matter what happens, Daddy and Mommy will always love you, and you will also love us; love will never change. That's faith." At the time, he nodded as if he understood. And twenty-seven years later, he is not only starting a personal exhibition but also publishing a book of photography. This convinces me that he took my words to heart. Now I hope only that Juan Sea will treat photography as I do – as his faith.

Words - **Juan I-Jong** (Photographer)

● **你如何開始手機攝影？**

我欣賞美的東西，大學的夢想是擁有一台蘋果電腦，現在自己也是蘋果產品的消費者。其中我尤其喜歡iPhone，不僅體積輕薄，攝影功能又非常方便。受到父親的影響，我也會想要記錄身邊的事物，就拿起手機，在旅行時拍下我所看到的畫面。

過去的工作經歷？

我一直是從事銷售性質的工作。退伍之後曾待過蘋果電腦，也做過保險業務、設計顧問公司的窗口等等，後來踏入家具業，在「覓得」大安店當店長，目前則於臺北經營「阮義忠攝影工作坊」。

這些經驗是否對創作態度產生影響？

這可以從工作以前的事開始談起。我大學念的是社會福利系，畢業後原本是海軍，但抽籤抽到社會役。我們用分發決定服役單位，當時考試成績是最後一名，便被指派到高雄縣鳳山鄉的遊民收容所，跟流浪漢一起生活了兩年。工作內容是帶這些需要照顧的人去看病，申請失業、低收入戶補助，或是開著洗澡車出外替遊民打理儀容、發放餐食、量血壓、剪頭髮等等。我

How did you come to start phone photography? ——— I appreciate beautiful things. When I was in college, I dreamed of having an Apple computer. Today I've joined the ranks of Apple consumers. Among all Apple products, I especially like the iPhone. It's not only light and thin, but the camera functionality is also very convenient. I was influenced by my father in that I too want to record the world around me, so I use my cell phone to shoot the images I see when I travel.

What's your past work experience? ——————— I've always worked as salesman. After my military service I worked for Apple, then as an insurance salesman. I was the customer service contact for a design consulting company, and I later entered the furniture business and was store manager of the "MID" furniture store. I currently operate the Juan I-Jong Photography Studio in Taipei.

Did your work experience influence your approach to photography? ——— Let me start even earlier than my work experience. I majored in Social Welfare in college, and after I graduated, I did my military service in the Navy. We drew lots to determine assignments, and social services fell to me. The military distributes everyone into units by grades, and I had the worst test results, so I was assigned to a homeless shelter in Kaohsiung's Fengshan District. I lived with homeless people for two years. My job was to take them to doctors, apply for unemployment benefits for them, or drive the mobile shower unit to them so they could freshen up. We would also distribute meals, measure their blood pressure, and cut their hair, among other things. I saw quite a number of homeless people in very bad circumstances: some had mental health problems, some had AIDS, some were disabled, and a minority had been abandoned by their families. I realized then how hard it is to survive, and how most people can't decide their own fate. Most of the homeless were men, and some had a rich life before they became homeless. It made me conclude that men are more fragile than women. You often hear stories of a mother managing to

當時看到很多可憐的遊民，有的患有精神病、愛滋病，也有身體肢障、或是被家庭拋棄的弱勢份子，那時候我就覺得生存是件辛苦的事，不是所有人都能決定自己的未來。遊民以男性居多，許多人從前過著富裕的生活。這讓我發現，相較於女性，男人是脆弱的，你會常聽到母親辛苦地將四五個小孩帶大，爸爸卻不知去向的故事，碰到危機時，往往是女人一肩扛起家計，也許很多遊民也是這樣。他們常說自己以前很有錢，現在卻不願意面對現實而拋家棄子。但他們很樂意分享過去的經驗；尤其是失敗的經驗，都特別讓我作為警惕。

這些經歷讓我發現自己擅長與人相處、對人的觀察敏銳。業務工作一直是在分享我喜歡、我認為好的商品，這些工作讓我不斷地接觸人，並且了解人性，也將身段放軟，謙遜地從每個人身上學習。這樣的同理心，形成我攝影創作中的觀看角度。

許多攝影師若是接觸了社會底層、甚或社會的黑暗面，會用相對負面的方式做記錄，發表在都市安逸生活的人們無法直視、刻意回避、甚至視而不見的東西；但這些經驗卻刺激了你拍出有趣的、富有溫情的作品，這當中的關聯是？

難過、悲傷、黑暗的題材很多人處理過了，我想做的是記錄人性的光輝面（這其實是我老爸講的）。有人報導難過的事，總得有人報導開心的，而我選擇後者，希望大家看到這些照片會覺得生活其實可以正面而樂觀。

raise four or five children by herself though the father is gone. When there is crisis in a family, usually it is a woman who takes care of the family. Homeless men are frequently the fathers from these stories. Many of them liked to tell me how wealthy they once were, but how they left their wives and children because they couldn't face the reality of some crisis that occurred. They were quite happy to share their experiences however, especially their experiences of failure, and I was happy to learn from their experiences.

These experiences make me realize that I am good with people and that I am observant. While my sales jobs were about sharing products that I liked and believed in with others, my military jobs allowed me to meet different people, and to understand humanity while also keeping me humble. I strive to humbly learn from everyone. Compassion underlies the perspective in the photographs I create.

Most photographers tend to document the underbelly or dark side of society from a negative perspective and release their works into the mainstream, bringing that part of society to people who are less likely to see it themselves, or who choose to avoid or ignore it deliberately. But your experiences with the underprivileged became your motivation to photograph interesting moments compassionately. Could you elaborate on that? ———Other photographers have dealt with the sad, melancholic, and dark themes. What I want to do is to document the bright side of humans – an observation my father made about my work, actually. Some people tell sad stories, and it's good if others tell happy stories; I choose to be one of the latter. I want people who see my photos to feel that there is a positive and bright side to life.

Many homeless people consider going to shelters similar to going to jail, but in the shelters they can actually be taken care of. They have

很多遊民以為收容所是監獄，其實在裡面會受到很好的照顧，可以洗澡、理髮、看電視、玩紙牌遊戲，有時我也會帶他們出去運動、散步。我曾經拍過一張癩腳遊民的照片：陽光斜照在他臉上，拐杖像是他身體的延伸，又像獵人手邊的槍，是他賴以為生又引以為傲的物件。鏡頭裡的他直挺挺地撐著拐杖，看起來很帥氣、很有威嚴。我也拍過許多有趣的照片，比如一群遊民對我做鬼臉、或是向我敬酒等等，拍攝當下的氣氛都是詼諧有趣的。我記錄的不是遊民在一般人想像裡的樣子，而是把他們可愛、溫馨的部分表現出來。

攝影技術上的習慣與偏好？

因為Instagram的軟體設定，讓我以正方形的格式開始攝影。據說Instagram創辦人的靈感來自Polaroid的拍立得，成像四面等邊是這家公司所生產的相機之特色，也是Instagram採正方形為標準的原因。我爸爸的著作《正方形的鄉愁》（臺灣版由遠流發行），裡頭便都是以傳統120尺幅、6x6的底片所拍攝的方形照片。這種規格的樣片不用放大就可以看得很清楚，跟我們在瀏覽手機照片時的感覺蠻接近的。

從小受父親影響，看了很多攝影書，特別喜歡Henri Cartier-Bresson、Elliott Erwitt、Josef Koudelka等街拍攝影大師的作品。我講究構圖中明確的幾何線條，企圖在快門裡凝結「決定性的瞬間」，期待自己也能在街頭捕捉到令人感動的一刻。

showers, barbers, TVs and poker games available to them. Sometimes I took them out to walk or do other activities. I once took a photo of a limping homeless man, The sun was shining on his face, his walking stick looked like an extension of his body, or a hunter's gun: the walking stick was both a tool of life and an object of his pride. He stood in front of the lens, back straight, walking stick in hand, and looked very handsome and dignified. I took many interesting photographs of homeless people. Some of them would make faces at me, or sometimes a group would toast me. The moments these pictures capture were funny and intriguing. What I want to document is not the negative side, but to show the cute, sentimental side.

Do you have any technical ritual or preferences when you are photographing? —————I started to take square photographs because of Instagram. Someone has said that the founder of Instagram was inspired by Polaroid – whose signature product created square photos – and chose the square photo format for Instagram as an homage. My father's book "Square-shaped Nostalgia" (Published in Taiwan by Yuan-Liou Publishing Co.) features square photographs taken using 120 film in the traditional 6x6 cm format. This size of print allows you to view the image clearly without enlargement. It has the same feel as browsing photos on our cellphones. My father's influence on me as a child leads me to read a lot of photography books. I like the styles of street photographers like Henri Cartier-Bresson, Elliott Erwitt and Josef Koudelka. When I photograph, I focus on geometry and clear lines in the composition, and I try to form a "decisive moment" with my shutter. I attempt to capture emotionally moving moments on the street on any given day.

What are the topics you want to engage and document?—————The amusing, the zany, and the humorous: something that brings me a knowing smile, something ironic or surrealistic. Also important to me is "tenderness". I have a photograph of an old couple crossing

關注與希望記錄的題材？

有趣、詼諧、幽默，能讓我發出會心一笑，帶些諷刺、超現實的，偶爾也富有溫情。我有張一對老夫妻過斑馬線的作品：老先生駝背嚴重，走路緩慢，老太太走在前頭卻不時回顧後方。他們看起來七八十歲，結婚數十年所累積的深厚情感全在這張照片裡透露出來。老先生有他的尊嚴，即使行動不便也不想讓人攙扶；老太太只是放慢腳步不斷地往後望，確認老先生的安全。我很容易被這樣子的情境吸引。

本書收錄許多於京都拍攝的作品，以攝影師的觀點，臺北與京都各自給你什麼樣的面貌？

臺北是我熟悉的城市。我喜歡騎腳踏車通勤，比走路快、比坐車慢，是一種很適中的速度，能在大街小巷到處跑，看見城市許多不同的樣貌。相較於京都，在臺北拍到的題材是可預期的，能夠記錄詼諧有趣的場景。我現在希望儘可能地離開自己熟悉的環境，接受新的感官刺激。

要到京都旅行，旅客一般會先在大阪落腳，但我通常直接抵達京都。有位朋友曾說，大阪像高雄，京都則是臺南，我完全同意。大阪是個大城市，京都則很好地體現了日本的歷史，但不只有老文化，還融入新城市的風貌，是一座時代揉合

the road. The old man walked very slowly because of his hunchback, and his wife walked ahead of him but kept looking back towards him. They were in their seventies, maybe eighties, and they'd probably been married for forty or fifty years. The depth of their emotional connection was captured in the photograph. The old man didn't want any help because of his pride, and his wife just kept her pace slow while continuing to looking back, making sure that her husband was safe. Scenes like this catch my attention.

This book collects many of your works taken in Kyoto. What are your impressions of Taipei and Kyoto from the perspective of a photographer?————Taipei is a city that I'm familiar with. I like to commute by bicycle. It's faster than walking, and slower than driving. It's the perfect pace to explore streets and alleys and see the many different sides of the city. In Taipei I can anticipate seeing more humorous and zany scenes than in Kyoto. These days I seek to be away from familiar environments to stimulate my senses with new experiences.

Most people will land in Osaka when flying to Kyoto, but most of the time I would travel to Kyoto directly. A friend once said that Osaka is like Kaohsiung, and Kyoto is like Tainan: I agree with that completely. Osaka is a bigger city, while Kyoto contains a richer history of Japan. But Kyoto is more than just old culture: as the new city landscape emerges, Kyoto sets a wonderful example of merging different times in one place. Here you see not only modern architecture, but also ancient temples and traces of culture. In Kyoto, my mind becomes peaceful and tranquil. It's easier there for me to capture peaceful moments and scenes of beauty.

What are the cities you would like to visit in the future?————I'd like to visit the whole world! I want to go to Thailand – Bangkok or

的典範。無論近代建設、古老的廟宇與文化痕跡，都可以在京都看到。在那裡，心情會非常寧靜，容易捕捉到安祥、美麗的情景。

未來想要參訪的城市？

全世界都想去看看啊！亞洲想去泰國、曼谷或清邁，韓國也很令人期待。泰國給我的印象是一個很刺激的地方，也有新、舊文化的結合，這種衝突很迷人。我相信藝術、設計等文化產業在泰國也已發展得很成熟，有文化的地方就容易發生有趣的事情，「衝突」會帶來諷刺與幽默。而韓國，我喜歡他們的建築與民族服裝，音樂、戲劇等娛樂產物大量地影響著臺灣，我很想看看他們的傳統。至於歐洲國家，則想到里斯本、威尼斯走走。我的攝影一定會以人為主，我對人很有熱情；應該說，我對具生命的事物是抱有熱情的。

你認為優秀的攝影師應該具備什麼條件？

清楚自己想要傳達什麼給別人，有很好的觀察力、眼界、以及表現力。當我們把攝影者的名字遮起來，作品是否還能讓人感到深刻？我想這是一個重要的標準。

Chiang Mai. Korea is exciting to me too. My impression of Thailand is that it's an exciting place that combines new and old culture together. This type of contrast fascinates me. I believe culture, art, and design have all evolved in a mature way in Thailand. If there is culture, interesting things happen, and clashes bring irony and humor. As for Korea, I like Korean architecture and traditional clothing, music, drama and other entertainment productions, all of which have had a large impact on Taiwanese culture. I really want to explore their traditions. If I travel to Europe, I'd like to see places like Lisbon and Venice, among others. My photography will always focus on people: I am passionate about people, in other words, I am enthusiastic about anything that has life.

What are the qualities of a good photographer?————————Someone who knows what he is trying to communicate to others, has good observation, vision, and expression. Someone whose work can impact others, even when the photographer's name is obscured – I think that's an essential standard.

Can you talk about few stories when you took photos?————————I like the photo of a group of female students hopscotching across the Kamogawa River (pictured, next page). I was travelling with a friend, it was a cold day – it even snowed a little though it rarely snows in Kyoto. River scenes in Japan are very beautiful in the fall and winter seasons: trees move in the breeze, children play around the banks of the river. At the time of the photo, my attention was drawn to people shouting. A group of school students, all in gymnastic clothing, were having P.E. class on both sides of the Kamogawa. It was like a scene that you would see in a Japanese teen drama. A group of girls were playing games on the riverbank. I had a feeling that something might happen so I lingered there and soon after, the girls gathered around the stone steps and began playing hopscotch. I captured the moment because I anticipated something happening. I learned later,

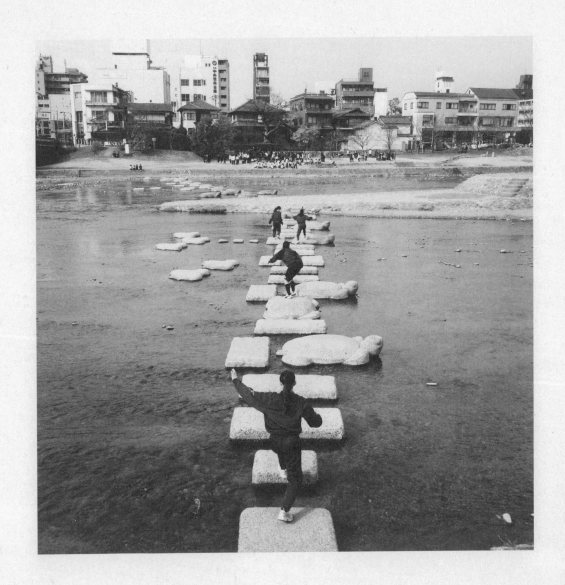

可以聊聊幾件作品拍攝時的故事嗎？

我很喜歡一群女學生在鴨川上跳石階到對岸的照片（左圖）。當時和朋友在京都旅行，天氣很冷，甚至有點飄雪（京都是很少下雪的）。日本秋、冬季的河川景色很美；風吹樹晃，孩子們在河岸玩耍。當時我注意到呔喝的聲音，一群國高中生在鴨川兩岸上體育課，他們身穿運動服，像是日劇或少年電影裡會看到的場景。幾個女孩子坐在河岸旁的石凳嬉鬧猜拳，我直覺會有事件發生，便留在那裡等，不過一會兒，她們果真在河川上的石階玩起跳格子；因為我對後續發展有所預期，才捕捉到這樣的畫面。後來我才知道，拍攝地點正好是鴨川的正中心，這更讓我覺得別具意義。

這幅作品對我來說是一個轉淚點，讓我開始督促自己每張照片都該到達這個水準。後來我再回到鴨川，卻找不到這個地方，當然那天也拍了一些東西，但都馬上就刪掉了。我發現很多事情是珍貴在當下，就算遇見一樣的人、一樣的環境，若我心境不同，就無法記錄相同的景象。倒是之後拍到兩個小朋友在釣魚，也算是意外地賺到了吧。他們一個站在岸邊、一個蹲在川上的石階，其中一位一邊聊天一邊以優雅的姿態將魚竿甩出去，形成很美的構圖。川上的男孩被水面映出倒影，有人說看起來像是坐著魔毯，我覺得這樣解讀也蠻有趣的。◪

第三張照片，拍攝地點在臺北松山菸廠。Instagram 上的手機攝影玩家不乏專業創意工作者，臺灣知名設計師王志弘亦是其

that the location was the center of the Kamogawa; I came across the center unwittingly, and that too, makes me feel something special and meaningful about it.

This photograph was a turning point for me. After it, I wanted every photograph I took to meet the same standard. I went back to the Kamogawa afterwards, and I couldn't find that spot again. I still took some pictures the day I went back, but I deleted them immediately. It made me realize that timing is what makes something special: if I met the exact same people, in the same environment, but if I were in different state, the result would've been different. But while trying to find it again, I caught another moment – this one of two children fishing, so it was a delightful coincidence! One of them was sitting on a stone platform in the river, the other standing on the shore gracefully casting his fishing rod while they talked – it formed a beautiful composition. Someone has remarked that the reflection of the sitting boy is as if he is sitting on a magic carpet – an interpretation that I find quite interesting. ◪

The third photograph was taken in Songshan Cultural and Creative Park in Taipei. There are some professional creative photographers on Instagram – famous Taiwanese designer, Wang Zhi-hong, is one of them. He takes great photos, and I had been browsing his work. He took a photo in Songshan Cultural and Creative Park during the Deaflympics in Taipei where, against the backdrop of a large promotional billboard of a hurdler in mid-jump, an old lady walks in the opposite direction, a photograph in which the subjects' directions intersect. After inquiring where the picture was taken, I made a point of going to Songshan Park, to this same billboard. Here I was able to capture the moment two monks holding umbrellas passed by, walking below and in the same direction as the hurdler on the billboard, as if the hurdler is attempting to leap them both. I really like this piece, and you could say I was inspired to take it by the work of Wang Zhi-Hong. ◪

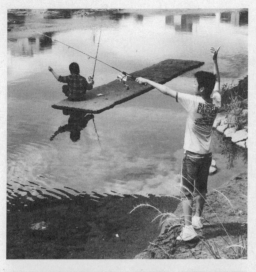
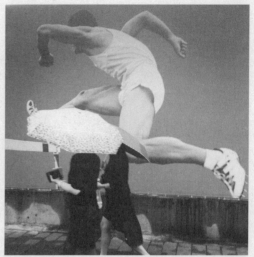
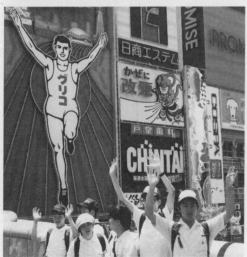

中一位，我一直有在關注他的作品。臺北聽障奧運籌備期間，他在松山菸廠的圍欄帆布四周，拍攝一位老太太正從躍過障礙的運動員底下、方向交錯地走過的照片，題材非常有趣。經過詢問後，我特別前往松菸，也在那裡捕捉到兩位女士撐著傘、和帆布裡的運動員往相同方向前進的畫面，與王志弘先生的手法相反，給觀者一種選手跨越兩人往前邁進的錯覺。我十分偏愛這幅作品，也可以說是從王志弘先生的攝影當中得到啟發。⊞

我一直很喜歡側拍人們在鏡頭下的狀態。人總是會在被拍照的時候擺出特別的模樣，在鏡頭前不會感到丟臉，反而自在地表現平常羞於行為的各種好笑姿勢與表情。

我見過很多人在大阪心齋橋上和固力果先生的看板合照，好像已經變成觀光客必定朝聖的行程。我經過時，也在那裡試了很多角度，但都拍不到對勁的照片。當我正想要離開的時候，看到一群啟智班的學生聚集在橋上，老師在旁邊要大家模仿固力果先生的動作舉手合照。我覺得他們好可愛，同伴之間傻傻地慫恿彼此，好像大家想要一起在這裡留個紀念，便趕緊按下快門。⊞

非常剛好地，下一刻老師便走過去替他們調整姿勢。我覺得自己記錄了那群學生最自然難得的樣子。回到臺灣沒多久，聽到看版被撤除的消息，就更慶幸當時有捕捉到那個消失的瞬間。

I have always liked to take pictures of people who are being photographed by someone else. Humans aren't embarrassed in front of the camera; they will pose in funny positions or with strange expressions they normally wouldn't use.

I have seen many people take pictures with the Mr. Glico billboard on the Shinsai Bridge. It seemed to be a must-do on tourists' itineraries. When I passed the place, I tried to take photos in different angles but it just didn't look right. Just before I was about to leave, I saw a group of special needs students whose teacher was asking them to imitate Mr. Glico to pose for a group photo. They were trying to remind each other to raise their hands, as if they really cared about seizing the moment. I thought they were cute, and I pressed the shutter right before the teacher went over to adjust their poses. I felt like I had documented the most relaxed and rare moment of these students. When I heard a few days later that the billboard had been taken down, it made me appreciated how fortunate I was to capture that specific moment. ⊞

Many boutique shop owners in Taiwan are quite eccentric. I once came across a chòu dòufu vendor in Taidong dressed in full paintball equipment, including a gas mask. It looked bizarre, but his chòu dòufu was exceptionally delicious. Dressing distinctively may simply be a personal preference, but despite any of that, his standards about the quality of his food were his highest priority. It's obvious to see the devotion of these local shop owners in providing quality products, while personal characteristics make them individually unique.

The last photo is of an eggnog juice bar called "Bastard Boss" which may be familiar to people living in the JianTan and Shilin area. His famous "Bastard Juice," (simply Papaya eggnog), was named to be playfully distinctive. The owner might even pour you a bit extra if you choose to enjoy your drink there. This is an example of the unique, friendly hospitality of the Taiwanese. He was wearing a bicycle helmet

在臺灣，有些小店的經營人非常有個性。我曾在臺東夜市看到一位老闆，全身穿著漆彈裝備、戴起防毒面具賣臭豆腐，乍看之下雖然突兀，臭豆腐卻意外地好吃。他們不是標榜奇裝異服，只是單純地喜歡扮成那個模樣，對品質還是有一定的堅持。從產品的用心，可以想見他們的態度是非常認真的，經營者的性格就成了小店的特色。

最後一張照片，是在臺北士林巷弄內的「混蛋老闆果汁店」。這間店的招牌「混蛋果汁」，其實就是木瓜牛奶加生蛋，只是老闆用戲謔的方式去包裝它，開了客人一個玩笑。如果選擇內用，老闆或許還會給你一杯半的份量，這也是臺灣特有的人情味。拍攝當天老闆戴著單車帽、穿著緊身車手褲，他可以說是臺灣勞動族群的象徵，努力地將自己喜歡的事做好，用幽默的態度面對人群與社會，認為把自己的小店妥善經營就是一件大事。只要讓客人嚐到一杯好喝的混蛋果汁，他就很滿足了。⊞

作為攝影家阮義忠先生的獨子，你認為在創作方式上受到哪些影響？

大約在我五、六歲的時候，爸爸正在拍公共電視的紀錄片「映象之旅」，團隊裡有雷驤、杜可風、張照堂這幾位文學、攝影界的大前輩，我那時候就被爸爸帶著到處跑。以前在家裡會看到很多大張的黑白照片掛在牆上；小時候只覺得奇怪，怎麼經常聞到糖醋排骨的味道，後來才知道那是定影液、急制液等沖洗底片用的藥水散發出來的氣味。暗房裡總會有很大聲的

and tight bike pants on the day this photo was taken, almost symbolising the general working class in Taiwan – hardworking people who treat everyday life with humor, believing that even managing a small shop could well be doing something significant and meaningful, and it brings him satisfaction to give every customer the tastiest possible "Bastard Juice." ⊞

As the only child of photographer Juan I-Jong, what influences has he had on you?——— When I was about five or six years old, my dad was making the documentary, "The Journey of Impression" for Public TV. Important figures in the literary and photography world such as Lei Xiang, Christopher Doyle (Du Ke-Feng), and Chang Chao-Tang were part of the team, and my father took me everywhere he went. I used to see many large black and white prints hanging on the walls and I often thought how strange it was that there were always a smell of sweet and sour pork around it. I realized later that it was the smell of fixer, stop bath and other chemicals using for developing film. In the darkroom, my father used to play classical music loudly. It's his work ritual. I heard this music over and over again growing up. Even now, I make connections between the music and these memories. Father is also a publisher and critic: he founded "Photographers International" magazine and he wrote "The Masters Of Contemporary Photography" and "Young Talents of Contemporary Photography," among other books. Anyone who has been in the publishing industry probably can imagine that my house at that time had an incredible number of books. The house was old, and it leaked when it rained. We often needed to find buckets to gather leaking water, so that we could protect these books and magazines. I think my impression of photography as a very hard job might be the result of seeing my father very busy all day long.

I liked to draw when I was little, but I was suppressed by the education system when I was in junior high school. At private school I was

古典樂，是爸爸工作時的習慣。我從小到大就反覆聽著這些音樂，到現在仍會與過去的回憶產生某種連結。爸爸也是一位出版、評論家，他曾創辦《攝影家》雜誌、寫過《當代攝影大師》、《當代攝影新銳》等書。做出版的人大概可以想像，我們家當時常堆著一疊疊的書。記得小時候的房子是老建材，下雨時就得接水，保護那些書與雜誌。也許是看著這樣整天忙碌不停的爸爸，從小對攝影的印象就是件特別辛苦的事。

我小時候喜歡畫圖，但國中被教育體制壓迫，在私立學校每天被體罰，喪失了創作的能力。直到進入大學，對音樂、藝術的興趣才突然都回來了。隔了近十年，父親的收藏對我多了一份意義，讓我回頭再去閱讀那些攝影作品、畫集與音樂，我也才開始拿起相機嘗試拍照。大學一年級時，我覺得自己有天份，便拍了些黑白照片。但我爸嚴格的，對整理作品、沖洗底片等等都很注重規矩。我大概玩了半年，不夠堅持，就沒有繼續下去，但這些身教及刊物直到現在仍影響我的創作方式。

爸爸很尊重被攝者，他認為相片的百分之五十決定于拍攝對象，剩下的才是攝影師的功勞。所以拍照的人應該要保持謙遜，或許對象未必這麼上鏡，但你透過攝影凝結他最美的時刻；思考如何表現對方的美，拍出良善、具敬意的照片，或許這不僅是創作，而是一種價值觀。

雖然攝影的啟發來自父親，按快門的瞬間卻受到母親很大的影響。媽媽幽默、善解人意，這培養了我觀看人、事的態度，我

punished physically everyday and I lost my ability to create. Only when I later enrolled in college did my interest in music and art return to me. It was then, ten years later, that my father's photography collection began to take on new meaning for me. My rekindled enthusiasm for the arts led me to return again to those photography works, catalogs and music and I began trying to take pictures. In my freshman year, I thought I might have some talent and took some black and white pictures. But my father is very strict; he pays a lot of attention to the rules of organizing the works and the process of developing film. I did it for about half a year, but I wasn't determined enough and in time, I quit. But what he had taught me and his vast collection of publications have had a lasting impact on my photography.

My father respects the subject of photographs: he thinks that the subject determines fifty percent of a photograph, and only the remainder is the photographer's work. Therefore a photographer should always be modest towards his subject. Even if the subject isn't very photogenic, the photographer is obligated to capture their best moment. A photographer should think about how to express the beauty of the subject, and to produce photographs that are kind and respectful of his subjects. Photography is not just about creativity, it is also about one's values.

My father inspired me to take photographs, but the moment that I choose to press the shutter is most highly influenced by my mother. I think my personality is similar to my mother, in that she is humorous and empathetic, and that has affected my attitude in observing people and things.

Since I was a child, my father told me not to be a photographer because it's very stressful, but also because there would always be

想我的個性比較像媽媽，作品中的詼諧也許是來自於這裡。

我爸從小就叫我不要踏入這一行，說我的壓力會很大，作品會不斷被拿出來與他作比較。他總說要拍可以，但當成興趣就好。藝術當作興趣與職業是完全不同的，一旦作為職業，就必須像是燃燒生命般去創作，若沒有這種覺悟就乾脆不要碰。但其實小時候我根本就不想拍照。

我曾將在大學期間拍下的照片給他看，他拿在手裡咻咻地快速翻過。我說，誒，可以看慢一點？「別人翻我的書不過也就是這樣子而已。」他這麼回應。後來用手機拍照，認真地累積了一年的作品之後，戰戰兢兢地拿給他，結果卻完全不同。

他曾把看我作品的經歷寫成一段故事。他說，有天我突然要請他和老媽吃飯，他很驚訝；飯後到了一間咖啡店，我才把手機拿出來，而我媽在旁邊說：「兒子在拍照，還不錯，看一下吧。」

爸爸看了照片以後，說真的不錯，沒發現我在拍照、而且拍了這麼多。他建議我再靠對象近一點，嘗試接近對方，同時不讓他產生防衛；我們與被攝者的距離決定了是否可以繼續拍下去。能夠得到父親的讚許，遠比任何人的肯定重要，也讓我對攝影更有自信。第二年就和爸爸在臺北「空場」辦了一場聯展，正式地以攝影師的身份出道。

comparison between my works and his. He always said that I could take photos, but to treat it only as a hobby. It's completely different to see art as an interest, than to see art as profession. Once you consider it a profession, you have to create works as if you are burning yourself. If you don't look at it this way, you might as well not do it at all. But when I was younger, none of that mattered to me because I didn't want to take photographs at all.

I once showed him the photographs I took when I was in university. He browsed through them really quickly. I said, "Hey! Could you turn the pages more slowly?" He replied, "That's the way other people browse my books." Later in my life when I used my cellphone to take photos, I had worked very hard to produce works for over a year, and I was intimidated to show him my work, but it turned out he had a completely different reaction than I had prepared for.

He once wrote the story of first looking at my works. He said, one day, out of blue, I surprised him by asking to treat him and mother to a meal. After the meal we went to a coffee shop, and it was then that I took out my cellphone and my mom sat next to me and said, "Your son is taking photos and they're not bad; take a look." After my dad saw the photos, he said they weren't too bad and that he didn't know that I was taking photos, or that I'd taken so many. He suggested I try to get closer to my subjects and try to approach them as much as was possible before causing them to feel defensive. The distance between us and our subjects tells us whether or not we can continue photographing them. Having the acknowledgement of my father is more important than anyone else's. It also makes me more confident with photography. The following year my father and I organized a joint exhibition at the Polymer, and I officially started to work as a professional photographer.

對你來説，手機與傳統攝影器材所詮釋出的作品，有什麼樣的相同與相異性？

手機便利，可以説是眼睛的延伸，從口袋拿出來就能拍，比傳統、數位相機都更具機動性。即使畫質確實無法與專業相機比較，但有了數位攝影之後，被攝者甚至不知你正在拍他，這是傳統攝影器材無法做到的。雖然不必如傳統相機，必須沖洗底片才能知道快門是否成功，但數位相機的出現，也讓「快門機會」因此變得很廉價。

傳統相機雖然有不便的地方，卻能夠讓攝影師學習觀察與等待，專注在每一次按快門的動作上。對很多攝影師來説，屏住氣息去捕捉瞬間，相當于一種儀式。很多人説現在已經沒有決定性的瞬間了，誰都可以利用後製軟體去改變影像，讓它成為自己想要的樣子。但我認為好的攝影師仍然會追求作品的一氣呵成，並且用傳統的攝影精神看待創作。手機有好的地方，但我們還是不能忘記傳統攝影的核心價值與創作態度。

你與父親共同經營臺北空場的「阮義忠攝影工作坊」，邀請許多中國年輕攝影師到臺灣展出。你對中國新一代追求傳統攝影脈絡的創作者有什麼想法？與臺灣的新一代攝影師又有何差異？

在數位化的時代，各個領域都會遇到門檻降低之後，創作者就不再認真思考何謂攝影、何謂設計、何謂做音樂這類問題，不

What are the differences and similarities for you of using a cellphone versus a traditional camera? ——————A cellphone is convenient. You could think of it as an extension of your eye. When you take it out of your pocket you can take a picture immediately. Its mobility is significant in comparison to a traditional camera or even a digital camera. The resolution, however, can't compete with a professional camera. With digital photography, subjects may sometimes not even be aware you're taking pictures of them. That's not something that can be done with a traditional camera. Because we don't have to wait to find out the results after developing film, digital cameras have removed the cost of pressing the shutter. While there are disadvantages to traditional cameras, one advantage they do have is to help train photographers to learn to observe and wait, so they learn to focus on the moment they press the shutter. The process of holding your breath in order to capture just the right moment is an almost unconscious ritual to many photographers. Many people say there isn't that same decisive moment anymore and that people can simply use post-production software to alter the picture and change it to be the way they want it. But I think a good photographer will still pursue completing his works in the viewfinder and value his creation in the spirit of traditional photography. Cellphone photography has its advantages, but we should remember the core values and attitudes of traditional photography in creating photography works.

Your father and you operate the Juan I-Jong Photography Studio in the Polymer studio space, where you've hosted many exhibitions for young Chinese photographers. What do you see in the new generation of creators in China, and how are they are following the context of traditional photography? And what are the differences between them and new generation Taiwanese photographers? ——————The entry threshold of media disciplines in the digital age is being lowered. As a result, each media discipline encounters the problem that today's new artistic creators spend less time thinking about the process of creating photography or, designing, or making music.

像過去資訊匱乏、器材短缺時的創作者這麼執著、認真、深入地去比較與學習。「阮義忠攝影工作坊」的影像空間平台，就是希望能在這樣的環境裡發掘認真的創作者。父親過去在辦《攝影家》雜誌時也是這樣，在全世界尋找不見得有名、但作品夠好的攝影師引薦給讀者；我們的影像空間延續這樣的精神，寧可雪中送炭，不必錦上添花，希望能不斷地介紹好的攝影師。

我看到中國攝影師的作品會覺得很新鮮，那是我不了解的地方。他們拍鄉村，就會覺得都市有趣；我們在都市待久了，也會覺得鄉村題材有意思。最近在「空場」展覽的兩位中國攝影師，分別只有十九歲、二十三歲，都是我父親的學生。雖然年輕，但作品成熟，這種情形在大陸很常見，優秀的年輕人很多，出版社的社長可能只有二十五、六歲。這兩位攝影師明顯超越了他們這個年紀所該有的表現，在自己的國家也許沒有很多發表作品的機會，所以能來臺灣展出都非常高興。

你開始攝影是以Instagram為契機，可以聊聊這個平台上的創作文化嗎？

現在很多人用手機拍照。只要懂得觀察、並且有能力傳達想要描述的主題，甚至可能比專業攝影師還厲害。以前礙於器材，很多人卡在技術面而無法拍好，但現在手機很方便，而且畫質逐年提升，照片可以輸出成很大的尺寸。我身邊的朋友都很會拍照，有些人甚至只在Instagram上發表，也會用Instagram去學習如何創作；例如喜歡商業攝影，就會密集地從商業攝影師的作品集尋求靈感。雖然這沒有錯，但我認為多了解攝影史、研究攝影大師的創作脈絡，才會知道什麼是真正的好照

Yesterday's artistic creators compared different outcomes and learned from hard work, intensive research, and through persistence in a time when they had limited information resources and scarcity of equipment. The space we provide in the Juan I-Jong Photography Studio is one where we hope to discover talented artists who are serious about their work. My father had the same mentality when he worked on the "Photographers International" magazine. He wanted to look for good, undiscovered photographers and introduce them to his readers. We want to continue in that spirit with our studio space: we would rather give opportunities to the unknown artists than praising those who are already famous. We hope to keep introducing good emerging photographers.

I find the works of Chinese photographers refreshing and intriguing. It's a place that I don't know very well. Since they mostly photograph the countryside, they might think cities are more interesting. Similarly, after you've stayed in the city long enough, you may start to think that the countryside is refreshing. At the moment there are two Chinese photographers exhibiting in Polymer, one is nineteen years old and the other is twenty-three years old. In spite of their young age, their artworks are mature. This is quite common in China: there are many talented young people. An established publisher, for example, may be no more than twenty-five or twenty-six years old. These two photographers displayed their talent in a relatively young age. They might not have many chances to show works in their own country, so they are very happy to be able to show in Taiwan.

You started your creative platform from Instagram, could you talk about the culture on this photo platform? ———Today many people use cellphones to take pictures. If you are observant and you can express what you want to say it's possible that your work could be better than a professional photographer's work. Many people in the past couldn't get good pictures because they didn't have the technical skills

片，產出的作品也會更有力道與內涵。

Instagram 可以打卡，還能將所有註記某個地標的照片彙整在一起，讓你看到在同一個景點有人分別記錄了不同畫面。這是我覺得很有趣的功能，我也會因此而去該地點取材。有一些使用者會 tag 很多分類，或頻繁到其他地方按讚、吸引注意，但是「讚」很多不一定代表照片好，千萬不要被數字影響判斷力。

對於飽受業界批評的軟體濾鏡，你有什麼看法？

雖然父親拍黑白照片，講求精準的不裁切、不格放，但他在教學時比較寬容，能呈現好結果就行。他常提醒學生，除了基本構圖，還要想想「是否有捕捉到當下的情境」、「是否把想說的表達清楚了」，我想這才是重點。我們玩 LOMO 會有特別的色調、黑白攝影也是抽離了現實的顏色。照片的好壞不會因為濾鏡而改變意義，失敗的照片用了特效也不會突然變好。

如何從「拿著手機拍照的人」變成一位「手機攝影師」？

有計劃性。我們可以在社群平台看到很多親友照、食物照，但攝影師與一般愛好者的差異在於是否有注重並思考構圖的表現

necessary, but with the ease of using today's cellphones and the ever-improving quality of the pictures they are capable of taking, you can print sizable enlargements of cellphone camera pictures.

Most of my friends are good at photography. Some of them only show their pictures on Instagram, and use it to learn photography. For example, if they like commercial photography, they will constantly browse works of commercial photographers to look for inspiration. There is nothing wrong with this, but I think it is essential to understand the history of photography, to look at the developing context of photography masters for learning what it means to be a good photography. It enhances strength and content of their works.

What's fun about Instagram to me is that you can "check in" at a location, and Instagram will collate all the photos from the same spot. You can see which people took what kinds of photos at the same location, and I may go to a certain location specifically for that reason. Some users use a lot of tags, or they may go to a certain location to "like" pictures so that they can get attention. But the number of "likes" doesn't necessarily equate to a good photo. Don't fool yourself by over-valuing with the number of "likes."

What's your opinion on using filters and other effects? ——— Although my father takes black and white photos, he insists on not resizing or cropping. But he is not so serious about these rules when he is teaching, as long as students have good results. He quite often reminds students to not only pay attention to the basic composition, but also to think about the moment. I think it is very important that they are clear with their messages. When we use a LOMO camera, there are special colors: the color of reality isn't black and white either. A filter doesn't change what makes a photo great, and on the other hand, a bad photo won't turn good because of a filter.

力。「這樣拍能否讓食物看起來更好吃？」「樹看起來更漂亮了嗎？」「微風吹拂時如何拍出樹木擺動的姿態？」等等；開始顧慮這些，就不再只是單純地按快門，有表達的企圖，就會用不同的角度去觀看世界。

你認為自己在目前的攝影環境裡扮演什麼角色？

我希望自己能持續創作、持續和讀者分享我的作品，把我相信的人生觀、創作觀傳遞出去。「阮義忠攝影工作坊」也會持續發掘新銳攝影師，讓有潛力的創作者被大家看見。我始終想當一個整合、分享者，期待藉由這個平台讓更多攝影師互相激盪，產生更好的作品，如果有機會，再將這些創作者集結起來，一起到國外展覽。

你希望藉由《院喜》帶給讀者什麼訊息？

辦過展覽以後，我發現iphone攝影功能的解析度其實挺好的，作品可以輸出到很大的尺寸。因為這樣，自己不斷在拍的東西有了新的定位；不只是生活記錄，還可以整理出來與更多人分享。許多人看過展覽後表示驚訝，不相信這些作品是用手機拍出來的。我想藉由這本書告訴讀者，無論是動態或光線，手機都能拍出不錯的效果；以及手機做得到、傳統器材卻無法做到的事。手機非常有可能變成未來的攝影主流，許多使用傳統相機的攝影家也開始用手機拍照，因為它有其不可取代性。當成

How can someone become a cellphone photographer instead of simply a person who uses their phone to take pictures? ———— You've got to plan your pictures. We see a lot of photos of family and food on social platforms, but what makes a photographer different from a photo enthusiast is their intention to express their composition. They ask questions like: "Can I make food look more delicious if I shoot it this way?" "Can I make this tree look better?" "How can I capture the movement of the branches in the breeze?" Once you start to think about these things, and stop just mindlessly pressing the shutter, you have created the intention to express, and you then see the world from different perspective.

For you, what role do you see yourself playing in the current photography culture? ———— I want to keep producing works myself, and continuing to share my works with others. I want to share my life view, my creative view with others. The image gallery in the Juan I-Jong Photography Studio will keep looking for young talented photographers who have yet to be discovered. I have always wanted to be a person who collects and shares. I look forward to making this studio space into a place where an increasing number of photographers can inspire each other and produce better works, hopefully even one day gathering these creators and exhibiting internationally.

What message do you hope to share with your reader in "Happiness in a Courtyard?" ———— After my exhibition, I realized that the resolution of the iPhone is actually surprisingly good – large prints can be made from the pictures. With that that discovery, I realized that the subjects that I have been working on take on a new meaning. They are not just documentation of an individual life, but can also be collected and shared with a larger audience. Many people at the exhibition expressed their surprise to me that these pictures were taken using a cellphone camera. I want to share the possibilities of cellphone photography with people; what is possible with a cellphone camera,

像能力越進步，手機攝影的應用價值也會越來越高。

對於想要嘗試手機攝影創作的讀者，你有什麼建議？

把手機攝影認真地當成一回事，它可以比你想像的做到更多。當你以嚴肅的態度創作，不管用哪種形式都可以做得很好，甚至能與許多傳統、數位攝影師的作品媲美，只要你足夠認真地看待它，並且持續有目的性地拍照。然後，務必勤快地整理作品，不然數位檔案要一口氣篩選起來可是很恐怖的。

口述·阮璽　　｜　　採訪及撰文·彭星凱

things you can't do with a traditional camera. Using a cellphone camera can result in a very good picture even if subjects are in motion or in poor lighting. Cellphone photography may become mainstream in the future, as more traditional camera photographers begin to take photos with their cellphones and because cellphones are becoming indispensable in daily life. As cellphone camera functionality increases, so too does the range of situations in which cellphone cameras can be used.

What's your advice for readers who want to use a cellphone camera as their creative medium? ————Take cellphone photography seriously. A cellphone camera can do a lot more than you might imagine. It's possible to take pictures well no matter how you take them. You can even compete with many traditional photographers and digital photographers as long as you are serious about the work, and you photograph with a clear purpose in mind. But one final piece of advice is worth mentioning: its imperative you organize your works diligently as you take them, otherwise it becomes terribly hard to organize all the digital files at a later time.

Interview - **Juan Sea** / Words - **Peng Hsing-Kai**

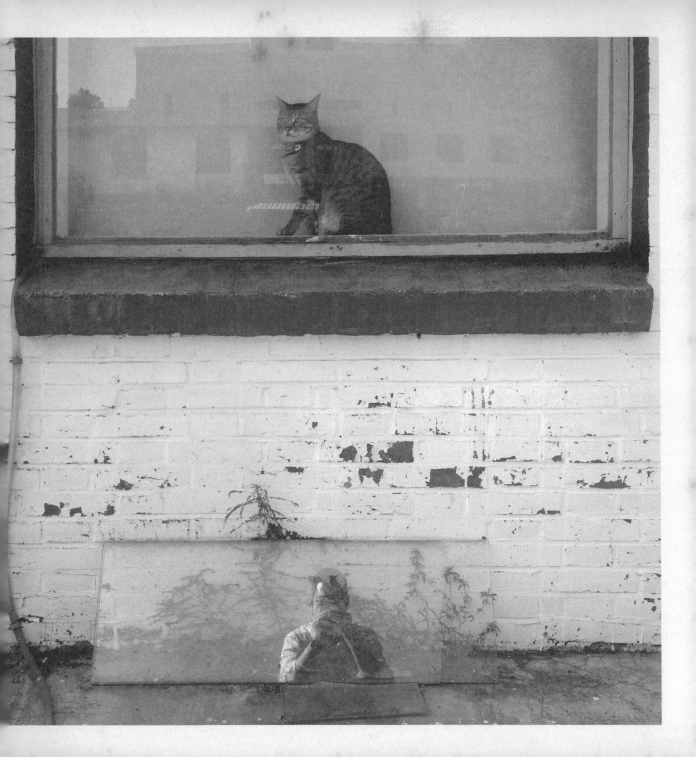

院喜　HAPPINESS IN A COURTYARD

作者・阮璽 ｜ 譯者・李彥儀、洪慧珍 ｜ 總編輯・彭星凱 ｜ 外語顧問・烏煦叡 ｜ 美術設計・空白地區 Workshop ｜ 出版・黑文化出版 ｜ 地址・臺北市大同區大龍街 177 巷 21 號 5 樓 ｜ Email・blackissue.fi@gmail.com ｜ 電話・02-25997720 出版總監・蔡南昇・一瞬設計有限公司 ｜ 合作發行・可口智造 www.cacaomag.com ｜ 印刷・海王印刷事業股份有限公司 出版日期・2015 年 1 月 初版 ｜ 定價 480 元 ｜ ISBN 978-986-90272-1-2

Author - Juan Sea / Translator - Lee Yen-Yi, Red Hung / Chief Editor - Peng Hsing-Kai / English Editor - Simon Walfram / Designer - Empty Quarter Workshop / Publisher - Black Issue / Address - 5F., No.21, Ln. 177, Dalong St., Datong Dist., Taipei City 103, Taiwan R.O.C. / Tel + 886 2 25997720 / Email - blackissue.fi@gmail.com / Director - Tsai Nan-Sheng - NST Design Co., Ltd. / Distributor - cacao intelligence - www.cacaomag.com / Printed by Hai Wang Printing Industry Co., Ltd. / Price 480 NTD